SUSSEX COAST
THROUGH TIME
Douglas d'Enno

AMBERLEY PUBLISHING

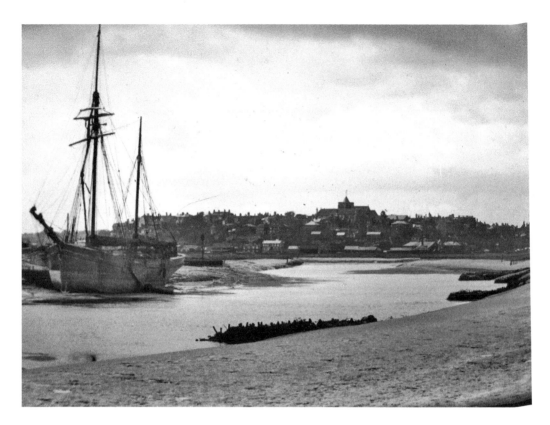

Rye and the River Rother, *c.* 1890.

First published 2012

Amberley Publishing
The Hill, Stroud
Gloucestershire, GL5 4EP

www.amberley-books.com

Copyright © Douglas d'Enno, 2012

The right of Douglas d'Enno to be identified as the
Author of this work has been asserted in accordance
with the Copyrights, Designs and Patents Act 1988.

ISBN 978 1 4456 0546 3

British Library Cataloguing in Publication Data.
A catalogue record for this book is available from
the British Library.

Typeset in 9.5pt on 12pt Celeste.
Typesetting by Amberley Publishing.
Printed in the UK.

Introduction

The making of this book was an exciting challenge. Before Amberley Publishing commissioned me to write and illustrate it, my 'territory' – like that of the majority of local historians – covered an area of several square miles. Suddenly, new horizons opened up, not only in terms of places but also of people. The acknowledgements overleaf show just how many local experts and residents gladly, and usually with no notice, shared their knowledge and thoughts with me. My research at numerous locations was charmed, inasmuch as the right person nearly always seemed to be on hand to provide the vital assistance needed. In return, I was in some cases able to provide them with one or more copies of images of their area that they might never have seen or have been able to possess previously. Comprehensive as online and book research might appear to be, the results could never be truly complete in a volume of this kind without the input from such helpers.

I am confident that the readers of *Sussex Coast Through Time* will find this journey of discovery to be as fascinating as I did when I undertook it myself.

Douglas d'Enno
Saltdean, March 2012

Acknowledgements

I am most grateful to the following individuals who responded, promptly and positively, to my request for information and help. Where contributors asked to have their affiliation noted, this appears within brackets. Space has not allowed me to specify individually the location to which their specialist knowledge relates.

Assistance with the text: Dhimati Acharya (Bexhill Library); Lucy Ashby (Littlehampton Museum); John & Diane Blase; Angela Bromley-Martin; David Brook; Moses Cooper; Gordon Dinnage; Sylvia Endacott; Jean Fawbert; Sandra Fisher (Selsey Life); John Goodwin; Nathan Goodwin; Martin Hayes (West Sussex County Council Library Service), Peter Hibbs; Samantha Hide (Local Studies and Information, Eastbourne Library); Terry McCarthy; Wendy Neve (Chichester Marina); Peacehaven Library; Pam Piercey; Julian Porter; Trevor Povey; Cyril Redman; Margaret Stevens; Nick Tree; Chris Wrapson.

Assistance with images: Peter Bailey (Newhaven Local & Maritime Museum); Ali Beckett (Chichester Harbour Conservancy); Ann Botha; Bob Cairns; Paul Davis; Caroline d'Enno; Neal d'Enno; Paul Daniell; Kevin Gordon (Seaford Museum & Heritage Society); Paul Gott; Martin Hayes (West Sussex County Council Library Service); Peter Hines; Bob Jones; Alan Keys (Photographic Restoration Services); Tracy Khoo; Becky Kirk; Mick Large; Ken Lee; Ruth Livingstone; Brian Lund; Jim Marsh; Lisa Mckinney; Vic Mitchell/Middleton Press; Julie O'Shaughnessy; Jessica Petit (Rustington Museum); Peter Sharp; Janet Smith; Jon Spence; Kerry Spinks (Tarmac Ltd, Newhaven); Andrew Stacey; Brenda Tompkins; Victorian-Era.co.uk; Lloyd Weedon (Tarmac Ltd, Newhaven); Sally White; Rendel Williams and Tom Williams. Maps: Thanks to Chichester Harbour Conservancy/Roger Smith for the map on page 94, and to Trevor Roman/www.sussexgallery.co.uk for the map on page 96.

Picture postcards, largely dating from early last century, form the backbone to this volume. I list below any publishers not already mentioned in the relevant captions and who have identified themselves: Austin & Son, Bognor; Otto Brown, Worthing; H. Camburn, Tunbridge Wells; E. T. W. Dennis & Sons Ltd, Scarborough; Lansdowne Production Co., London; Photo-Precision Ltd, St Albans; R.A.P. Co. Ltd, London; Russells (George Henry Allen), Chichester; J. Salmon, Sevenoaks; Shoesmith & Etheridge Ltd, Hastings; Charles E. S. Thomas, Bognor; Valentine & Sons Ltd, Dundee; Walker, Stratford-upon-Avon; Water Colour Post Card Co.; WHS ('Kingsway Real Photograph Series'). Readers wishing to learn more about the publishers of Sussex postcards in particular are referred to Rendel Williams' excellent website: www.sussexpostcards.info

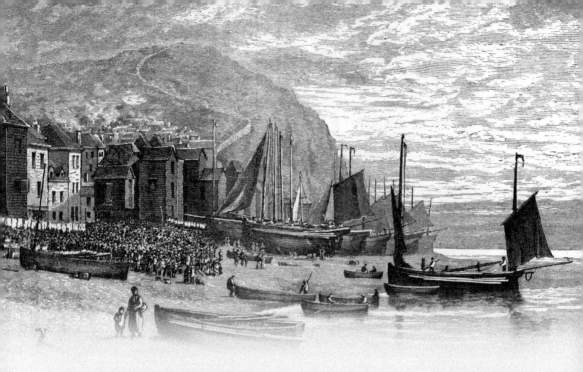

CHAPTER 1

East Sussex

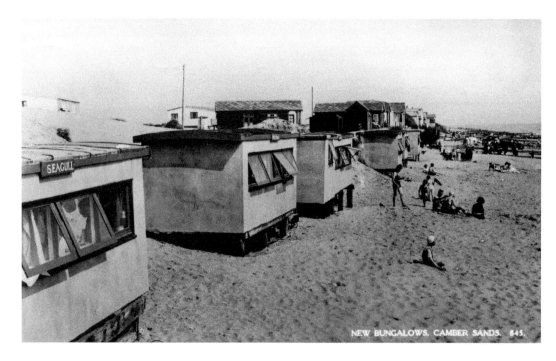

New 'Bungalows' at Camber Sands

Camber Sands, near Rye, boasts the only sand dune system in East Sussex. It is located east of the River Rother estuary at Rye Bay. The postcard above was posted in July 1946; the term 'bungalows' is perhaps overstated for what are effectively substantial beach huts. The second in the row from the left is named 'Wild Duck' and the third possibly 'Gannet'. The precise location is thought to be just east of the Kit Kat Café and today the dwellings shown stand near the site.

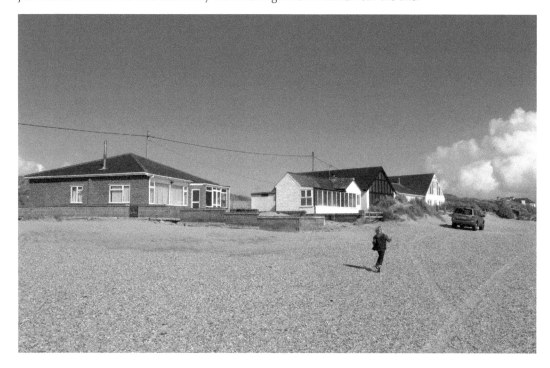

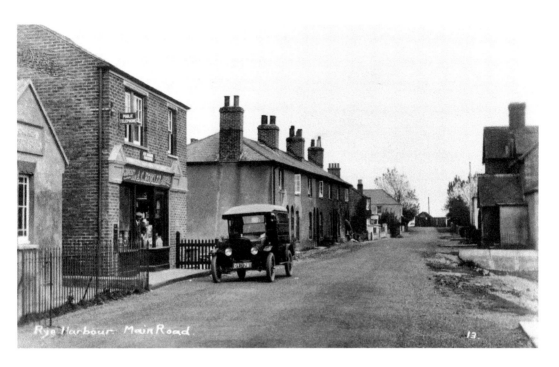

Rye Harbour Postmaster

In the above view, probably dating from the 1920s, Mr A. G. Hedgler peeps out from his shopfront in Main Road (today Sea Road). The post office sold grocery and confectionery and deliveries were made using Mr Hedgler's smart van. The premises have been replaced by a dwelling named Wavecrest, yet the postbox in the wall remains. The Methodist Church Mission room to the left has also survived as a residence. The row of houses is named Pain's Cottages. One of the female occupants appears to be entering by a window!

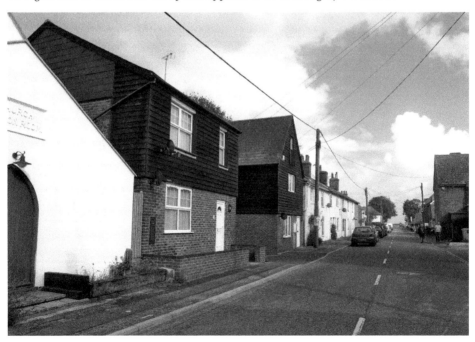

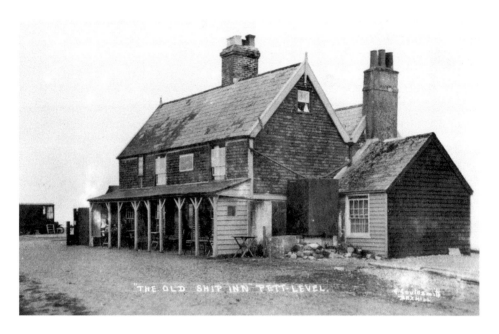

Old and New at Winchelsea Beach

The old Ship Inn dated from around 1742 and stood some 400 yards west of the junction of today's Environment Agency road with Pett Level Road. This image, by G. S. Goulden of Bexhill, shows the landward side of the building in the 1920s, when it was a popular haunt of locals and visiting celebrities from London alike. Two violent storms in August and November 1931 damaged and destroyed the inn. Its replacement, incorporating some timbers from the lost hostelry, stands some way inland on Pett Level Road, about half a mile east of the site of its predecessor.

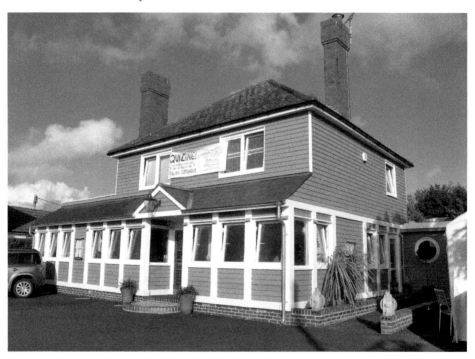

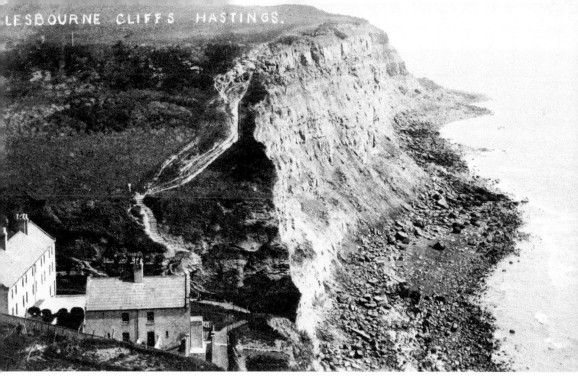

Casualties of Erosion at Ecclesbourne

The deep valley of Ecclesbourne Glen is located just east of Hastings and has featured on many postcards. In the one above, posted in July 1909, the foremost coastguard cottages appear vulnerable to erosion. Twenty years or so later they fell into the sea. All the surviving cottages were demolished in 1962, leaving just part of a boundary wall as a remnant of the dwellings. The fine modern image of this location was taken by Paul Daniell in June 2010.

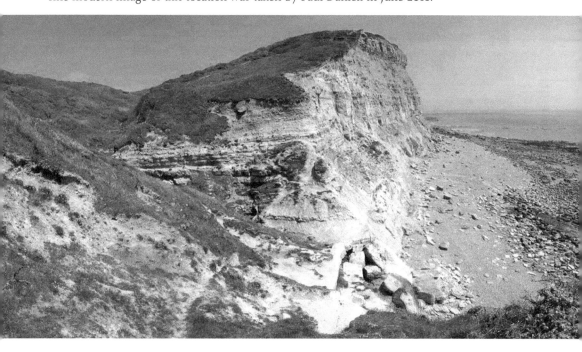

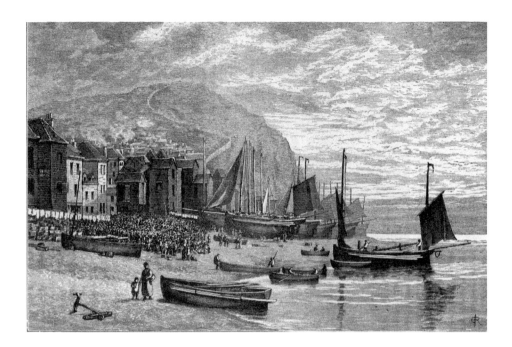

The Stade, Hastings

Perhaps it was some ceremony such as the blessing of the sea, or simply abundant catches, which caused a large crowd of townsfolk to congregate on the Stade, the area of shingle beach below the sandstone cliff of East Hill. This fine Victorian study comes from *Our Own Country*, a descriptive history published in around 1880. Prominent in both views are the tall, weatherboarded net shops. This is the last major beach-launched fishing industry base in the country.

On the cliff is the East Hill Lift, built in 1902. The development under construction is the Rock-a-Nore, named after this unique area of Hastings' old town.

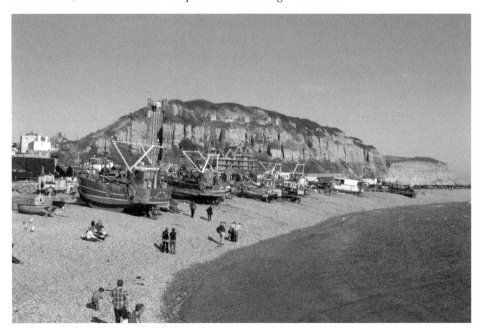

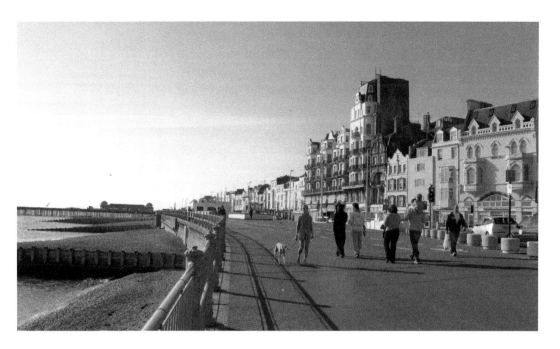

On White Rock Road, Hastings

We are near the junction with Carlisle Parade. The tall building on the right is the Grade II listed Palace Court, formerly the Palace Hotel, which itself replaced the White Rock Brewery in 1885. It was opened the following year.

The bandstand in the animated postcard below, published by prolific French publisher LL (Léon & Lévy), was moved to White Rock Gardens in the 1920s. The pier, in the distance in both views, was gutted in a disastrous fire in October 2010; it had suffered the same fate in 1917.

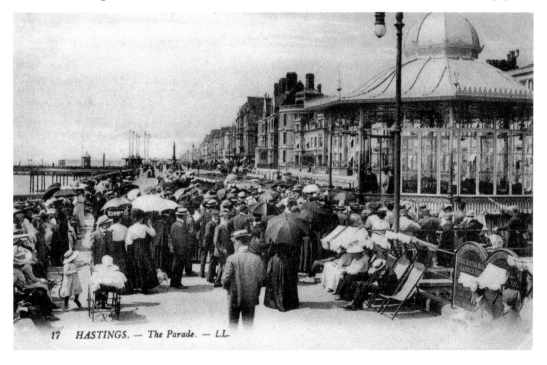

17 HASTINGS. — The Parade. — LL.

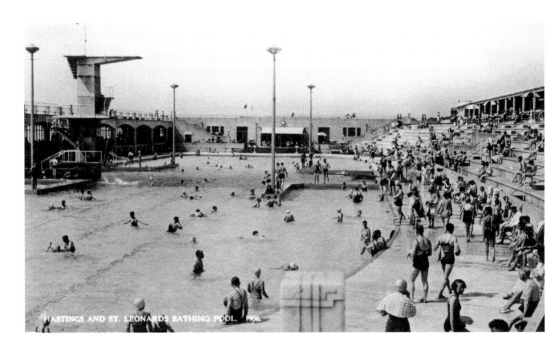

HASTINGS AND ST. LEONARDS BATHING POOL. 1906.

The Lost Pool, St Leonards-on-Sea, Hastings

Officially opened in 1829, St Leonards-on-Sea, Hastings' sister-town, was developed as one of the earliest purpose-built 'watering places' on the south coast. In 1875 the two towns merged into the County Borough of Hastings.

Sidney Little, Borough Surveyor 1926–1950 and known as the 'Concrete King', built this magnificent pool in 1933 at a cost of £60,000. Sadly, it only made a profit in its first year. Closed in 1959, it re-opened as a holiday camp the following year, later renamed the Hastings Holiday Centre. Closure came in 1986, with demolition of the derelict site taking place in 1993.

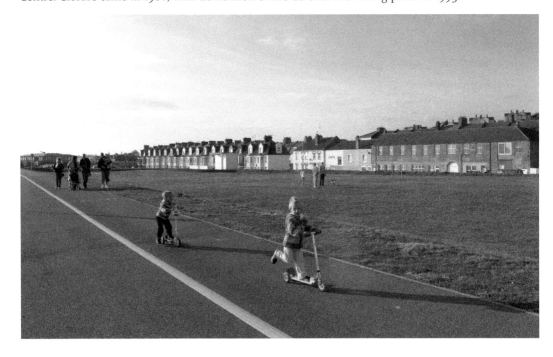

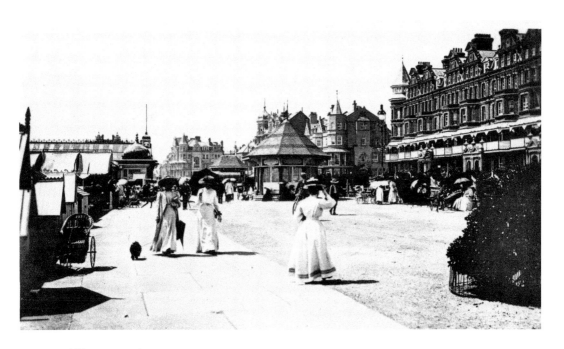

Bexhill-on-Sea: The Young Resort

Standing adjacent to the historical inland town of Bexhill, with its Saxon church, Bexhill-on-Sea was a latecomer among Sussex coast resorts, being promoted by the De La Warr family as late as the 1880s. It claims to be the first resort in the country to have allowed mixed bathing. It is also the birthplace of British motor racing.

 The early picture illustrates well the wide promenade alongside today's De La Warr Parade and the elegant Dutch gable terracing style of architecture favoured by the resort. The modern Glyne Hall flats occupy the site of the Glyne Hall Hotel, but the Rotunda shelter, formerly a bandstand, has survived.

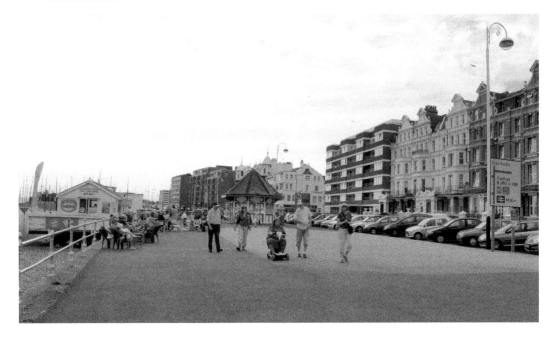

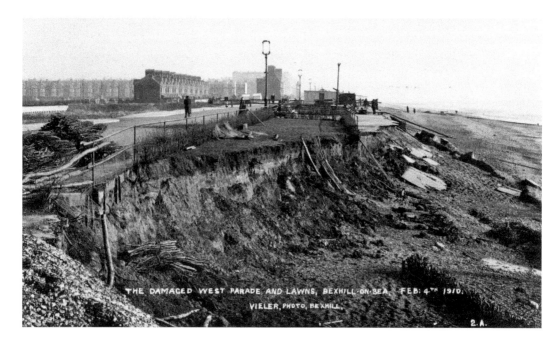

THE DAMAGED WEST PARADE AND LAWNS, BEXHILL-ON-SEA. FEB: 4TH 1910.
VIELER, PHOTO, BEXHILL.

Bexhill Takes a Battering

This dramatic postcard, published by Vieler of Bexhill (one of a set of five), ascribes the fearful damage on the West Parade and Lawns to a storm on or just before 4 February 1910. However, it was the storm of 14/15 February that the local press focused on. Described as 'one of the shortest and sharpest gales we have experienced for the past twelve months', it brought down the central portion of the front wall of the west bastion, which subsequently needed to be destroyed by explosives. Today no encroachment from the sea need be feared.

Interestingly, the apartment blocks below are each named after Windward and Virgin Islands.

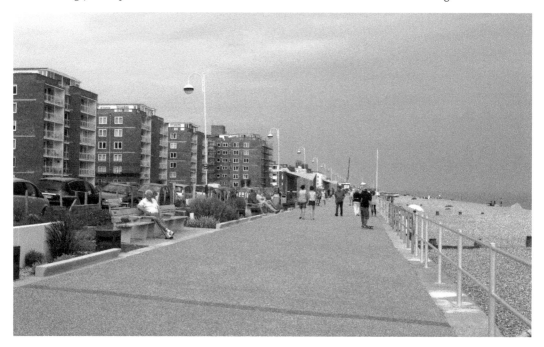

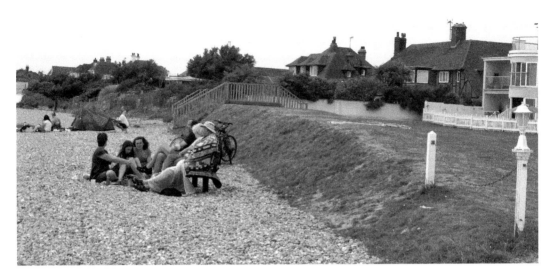

Enjoying Cooden Beach

This select residential area boasts a couple of hotels, a golf course (the club was founded by the 8th Earl De La Warr in 1912) and a tennis club and is located 2½ miles west of Bexhill. The two were formerly connected by a tram service; the roundabout by the nearby Cooden Beach Hotel of 1931 was once the turn-around point for the vehicles. A coastguard station stood opposite it. Nearby is the railway station, opened in 1905. One of the two houses on Herbrand Walk, seen in both images, now has a modern neighbour in the Sea House apartment block.

The Beach (West), Cooden.

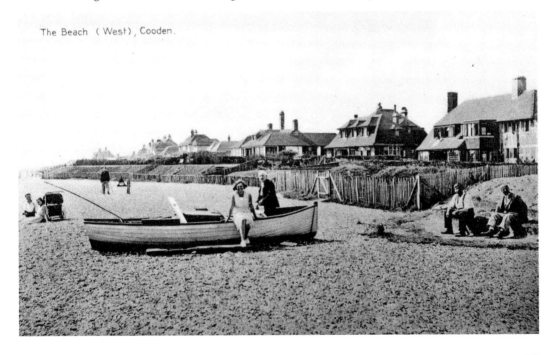

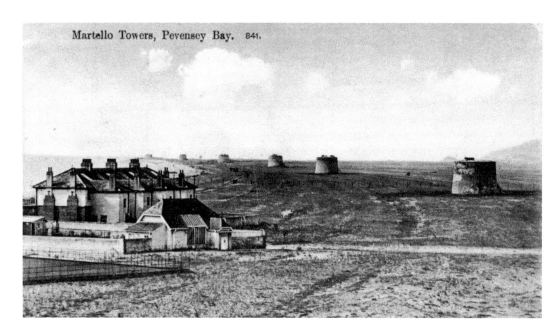

Martello Towers, Pevensey Bay. 841.

Line of Defence in Pevensey Bay

This view of the flat coastline between Eastbourne and Pevensey depicts part of the chain of Martello towers erected between 1805 and 1810 in response to the threat of invasion by Napoleonic forces. Along the south coast seventy-four towers were built, from Tower 1 at Folkestone to Tower 74 at Seaford (now housing the town museum). Only ten of the forty-seven towers in Sussex now survive; of these, six stand between Eastbourne and Pevensey Bay. The postcard, sent on 8 September 1910, shows, from left to right, No. 66 on Langney Point and No. 61, now a residence on the Martello Estate.

The once isolated Victorian houses (scarcely visible in the modern view taken from tower no. 60 by its occupant Paul Gott) today stand in a private cul-de-sac at the bottom of Val Prinseps Road.

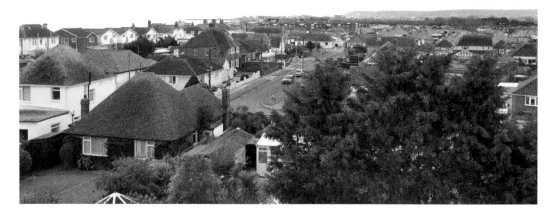

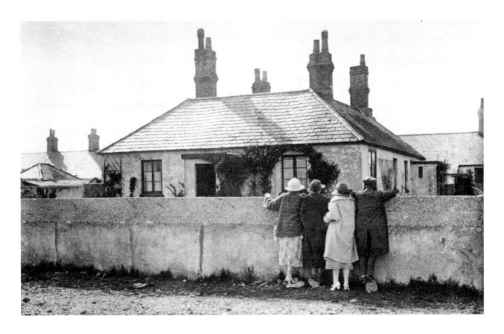

The Murder Bungalow on the Crumbles

In April 1924, in a former coastguard property on the desolate Crumbles at Eastbourne, thirty-seven-year-old typist Emily Kaye was murdered by her married lover, Patrick Mahon, thirty-four. Parts of the pregnant woman's body were found in a trunk and elsewhere at the rented love nest. Following an investigation, Mahon was arrested and tried. He was found guilty and hanged at Wandsworth Prison on 2 September 1924. The bungalow became a macabre tourist attraction under new leaseholders, who charged 1s and later 1s 2d to coachloads of visitors. The property, on the corner of Old Martello Road and Pevensey Bay Road (the A259), was demolished in 1953.

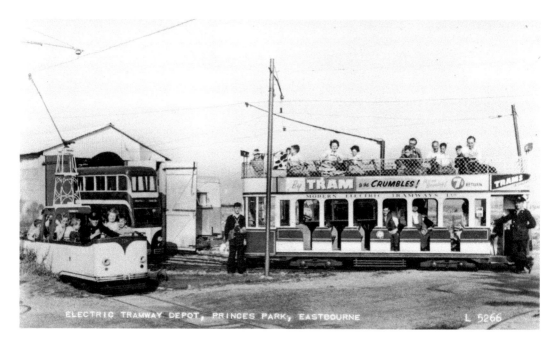

ELECTRIC TRAMWAY DEPOT, PRINCES PARK, EASTBOURNE L 5266

Happy Days on Eastbourne Tramway

Eastbourne's popular 2-foot gauge tramway was constructed in sections from 1954 to 1958. Journeys began in Royal Parade (Princes Park) and ended on the Crumbles. From left to right above are Car 4, a replica of Blackpool Tramway's 'Open Boat' design, still in operation in Seaton, Devon; Car 238, another Blackpool replica, sold to an American; and Car 6, based on the ex-Bournemouth open toppers of the Llandudno & Colwyn Bay system and now also in Seaton. The popular tramway closed in September 1969. In the centre of today's view stands the Spray Water Sports Centre.

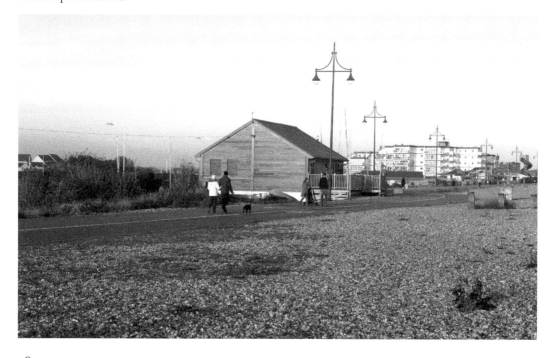

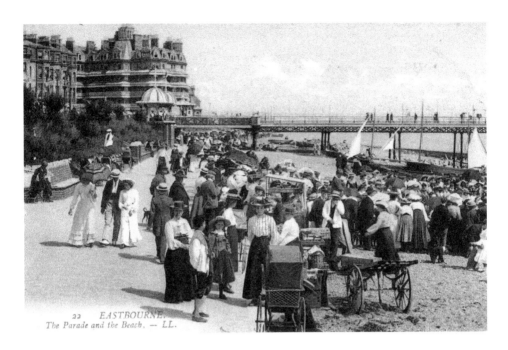

Eastbourne Prom, Beach and Pier

Developed as a resort from the early nineteenth century, Eastbourne is a popular tourist destination boasting record hours of sunshine. Its shingle beach stretches for 4 miles from Sovereign Harbour in the east to Beachy Head in the west. The pier, seen above in the animated postcard published by LL and posted on 29 August 1914, was designed by Eugenius Birch and opened in 1872. Crowds enjoy entertainment on the beach against the backdrop of the elegant Queens Hotel, built in 1880.

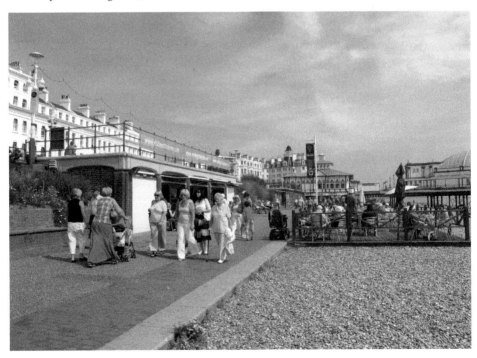

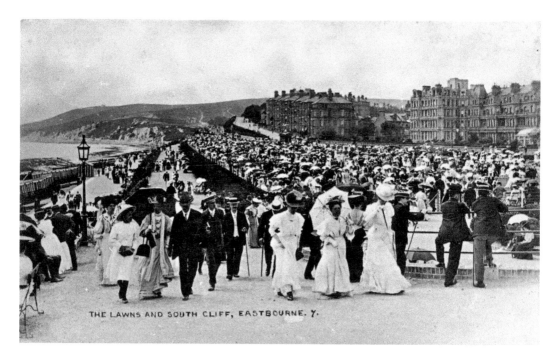

THE LAWNS AND SOUTH CLIFF, EASTBOURNE. 7.

Elegance on the Western Lawns, Eastbourne

In the warmth of a summer's day, fashionably dressed 'Church Paraders' enjoy the sea, the setting and each other's company. On 2 August 2011, by contrast, a handful of visitors and a few birds are to be seen. Out of sight on the right stands the bronze on granite statue of Spencer Compton, the 8th Duke of Devonshire, erected posthumously in 1910. In both images can be seen the magnificent Grand Hotel, dubbed the 'White Palace'. Opened in 1875, it boasts 152 guest rooms and no fewer than seventeen function rooms.

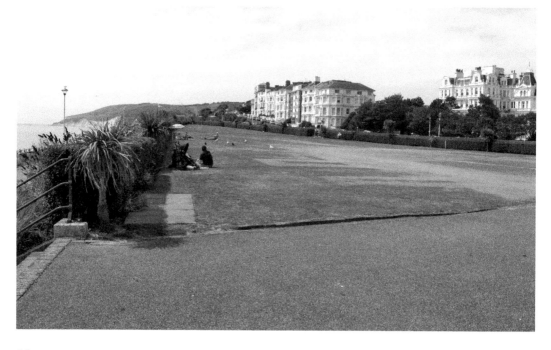

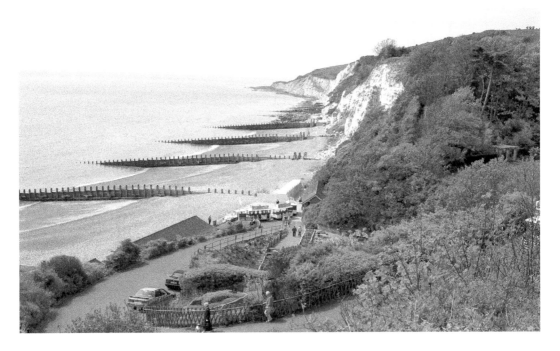

Tea at Holywell Retreat, Eastbourne

In Eastbourne's Meads district lies Holywell Retreat. These Italian Gardens were created by the Town Council in 1905 on the site of a disused chalk quarry known as The Gore, some 400m north-east of the old Holywell fishing settlement. To provide work for the unemployed, the Council put up a wooden, thatched tea chalet (later replaced by a brick-built café) and a promenade shelter between 1921 and 1923. The café, partly visible in the early postcard, is out of sight in the May 2006 view, contributed by Brenda Tompkins.

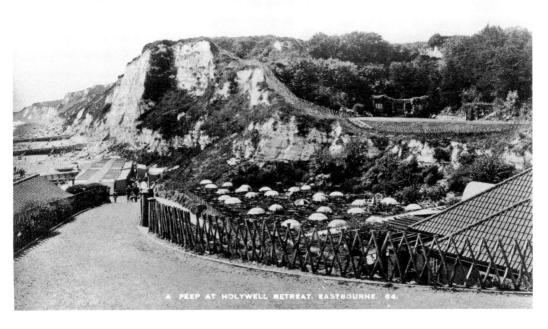

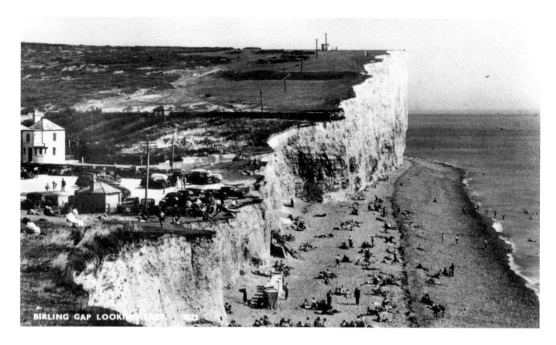

BIRLING GAP LOOKING EAST

Birling Gap

Erosion is a major problem in the National Trust-owned coastal hamlet and small resort of Birling Gap, not far west of Eastbourne, with the land retreating at the rate of some 0.75 metres a year. Crangon Cottages, originally eight coastguard cottages, date from 1878. They passed into private ownership in 1951, with four of them being purchased by the National Trust in 1983. Several have had to be pulled down due to erosion making them unsafe; the most recent demolition was in 2002.

The National Trust's stance that no coast protection measures should be taken was strongly opposed for nine years by the now disbanded Birling Gap Cliff Protection Association.

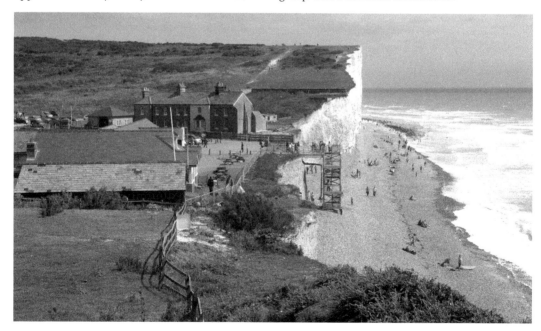

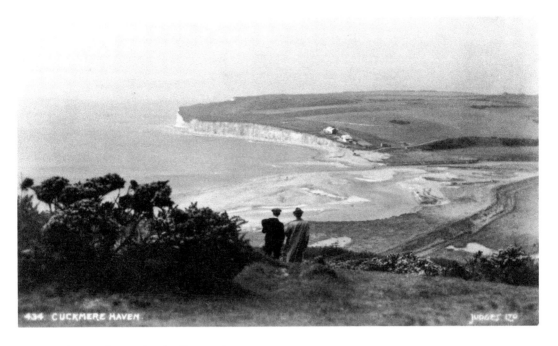

Cuckmere Haven Awaits Encroachment

This imposing view of Cuckmere Haven, by F. Judge of Hastings, dates from 1908/09. In the distance is the officer's house of the customs and excise watch and, higher up, are two larger houses in which were garrisoned twenty or so armed militia. The properties were built by the Navy in 1818 in response to rampant smuggling and shipwrecking activities. In 1840 they became a coastguard station, although this was decommissioned in the 1920s. Today, the houses – as at Birling Gap – are vulnerable to coastal erosion despite the defences. These were built by the residents themselves, since the Environment Agency is refusing to provide protection from the sea.

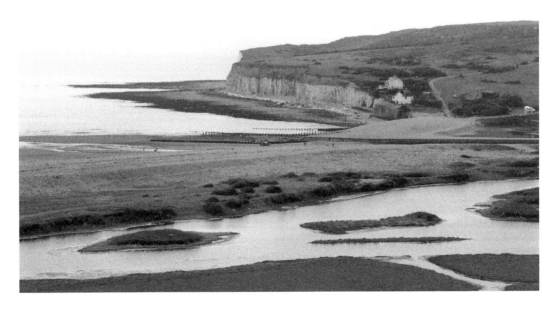

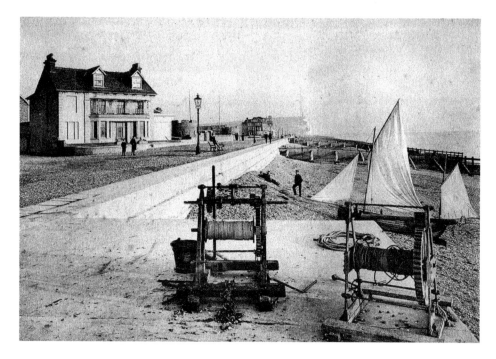

Seaford, a Changed Seafront

In this early beach scene, at the seaward end of Dane Road and against the distant backdrop of Seaford Head, we see Telsemaure House, built for local worthy Major Thomas Crook and his family in the early 1860s. The property, which had a schoolroom and large playroom as well as eight bedrooms, four reception rooms and two kitchens, was occupied by the family until 1901. Subsequently a hotel for many years, it later reverted to private use until its demolition in 1937. Today, the Viking apartments stand on the site.

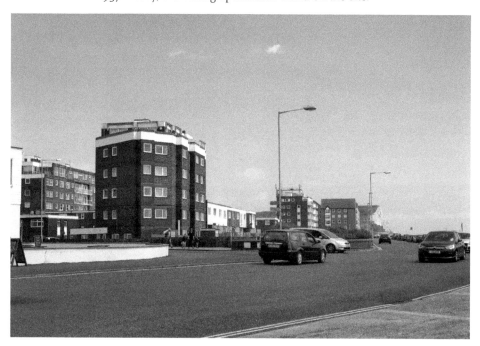

Seaford, the Coast Road West

Looking at today's Marine Parade, so secure from erosion, it is hard to imagine that the Buckle Road, as it was formerly known, was once so vulnerable to attack from the sea; at times it was completely impassable. Not until 1964, when by the Buckle Bypass opened well to the north of this site, was relief afforded. The Buckle – the symbol of the Pelham family – was the name carried by a nearby ancient inn, demolished in 1964. Its replacement is in place but has now been converted to a private residence.

The view below dates from September 1920.

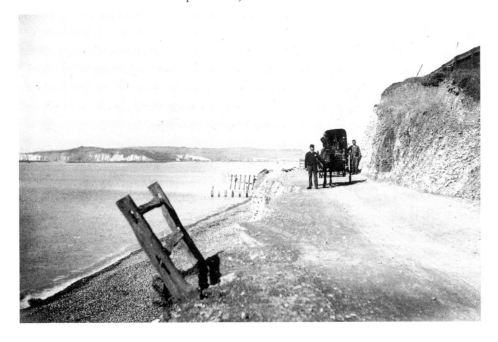

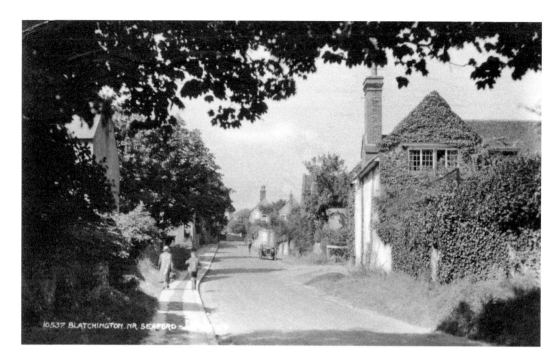

Seaford, East Blatchington

The ancient inland settlement of East Blatchington, west of Seaford, has been engulfed by the spread of that town's residential development. Milestones in the transition to suburbia include the sale of of the Alces Place farm buildings in 1956 for £8,500 and their conversion into homes. The twelfth-century church of St Peter still stands, however, although the village pub, the Star Inn, closed its doors as long ago as 1832. The property, converted from one to three houses in 1910 is now known as the Star House and is Grade II listed. It is the nearest building on the right in both pictures, which show the view from Blatchington Hill. The early image dates from 1928.

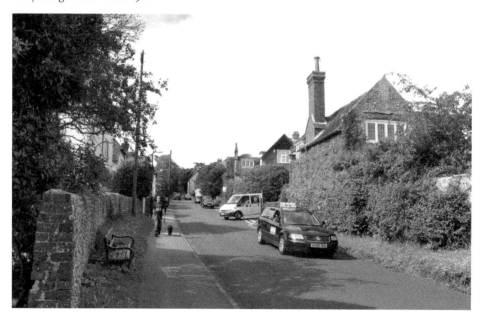

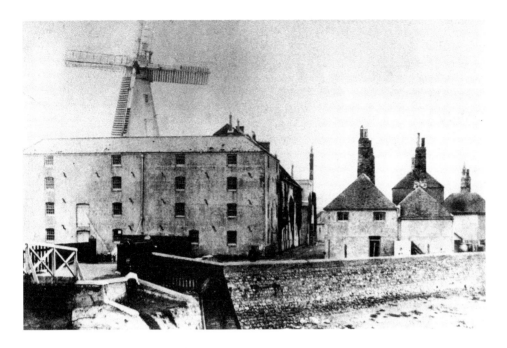

Seaford, Bishopstone Tide Mills

The hamlet of Tide Mills, established in the eighteenth century, was a self-contained community, which in the time of miller William Catt (1808–1853) boasted a mill-house, workers' cottages and three gates that were locked each night at ten o'clock. Here was the largest water mill in Sussex, using tidal energy from the Ouse for sixteen hours a day. It ceased milling in about 1876. The windmill was used for hoisting grain to the granary. Today the sole remnants of this busy hamlet, closed in 1936 and demolished as a defence measure in July 1940, are broken walls and exposed foundations, although the creek area, complete with information boards, is a popular visitor attraction.

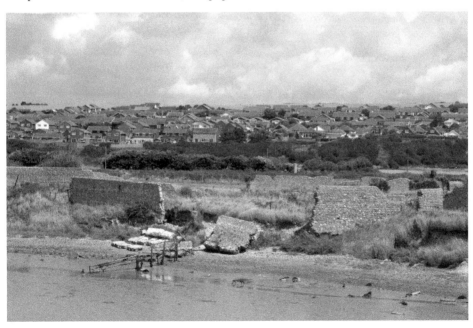

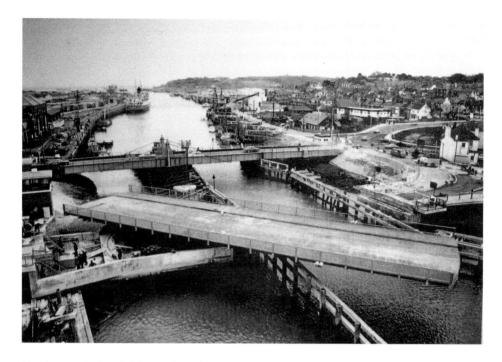

Newhaven, Swing Bridge and Harbour

This busy panorama of Newhaven Harbour and the River Ouse dates from 1974, the year the new swing bridge, here ready for positioning, was opened. As the only means of crossing the river on the South Coast, its periodical opening for shipping causes long tailbacks on the A259. Its manually-operated predecessor dated from 1866 and was a toll-free replacement of Newhaven's first bridge, the Act for which was passed by George III in 1784.

The 2011 photograph below was taken by Lloyd Weedon of Tarmac Ltd from the top of the company's gantry.

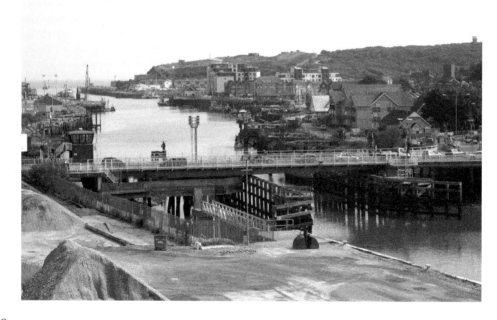

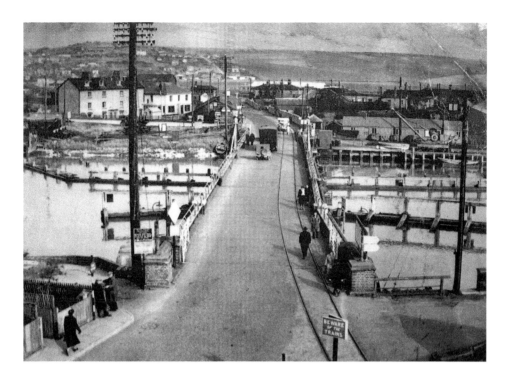

Newhaven, Swing Bridge, Looking East

This view is thought to date from the late 1940s and shows the earlier swing bridge, which carried the dock railway line. A tank locomotive, usually LBSCR 'Terrier' *Fenchurch*, would busy herself between the main line and the far end of the breakwater with maintenance, repairs and operations with oil tankers for refuelling the ferries. On the left near the opposite bank of the river stands Denton Terrace, demolished in about 1973, and in the centre the Railway Hotel. Both were sacrificed for the flyover. In the distance in both views is Mount Pleasant, near the village of Denton.

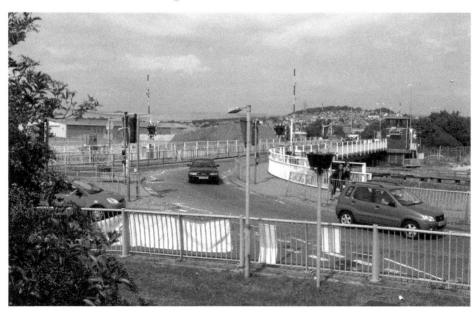

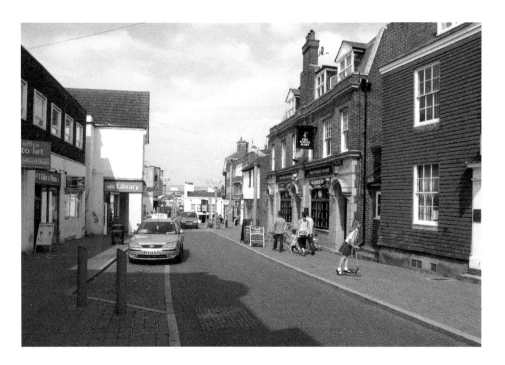

Newhaven, High Street

Today a ring road encircles the town's High Street and nearby roads, reducing the number of shoppers and casual visitors. The White Hart Hotel on the right was set back when the narrow street was widened in 1922. Almost opposite, the now lost Blue Anchor Inn of 1762 once stood. The animated postcard below, postmarked 6 October 1909, is a valuable record of the thoroughfare over a century ago. The distant Bridge Hotel (now once again the Bridge Inn) is a listed seventeenth-century building where Louis Philippe I, the last King of France, spent his first night in exile with his queen in 1848.

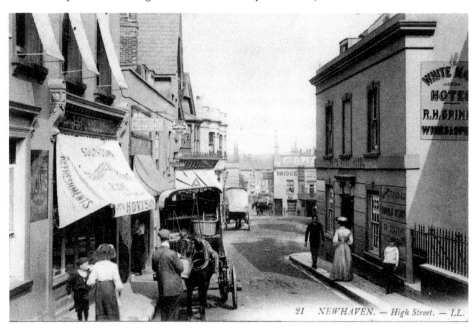

21 NEWHAVEN. — High Street. — LL.

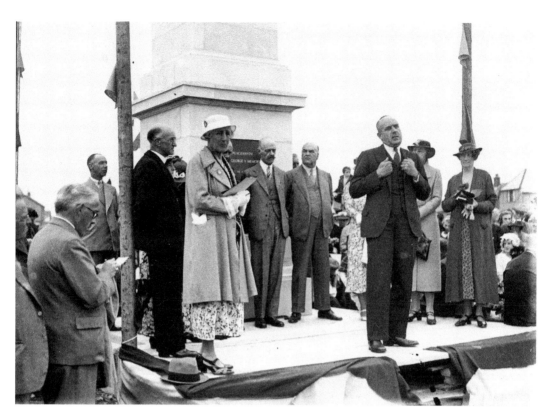

Peacehaven, the Meridian Obelisk

The relatively young town of Peacehaven (it dates from 1919) lies west of Newhaven. Its population of only 3,000 in 1924 has now more than quadrupled to exceed 13,000, while its area extends over two square miles.

The foundation stone of the Meridian Monument or King George V memorial and drinking fountain at the foot of Horsham Avenue was laid by the town's founder, Charles W. Neville, on 30 May 1936. The structure, originally planned to celebrate the Silver Jubilee, was instead dedicated to the king's memory following his death in 1935. It was unveiled by Neville on 10 August 1936.

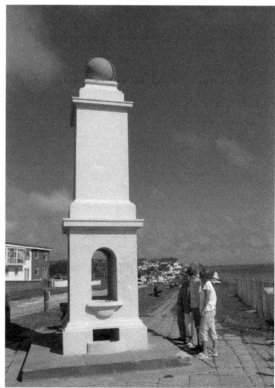

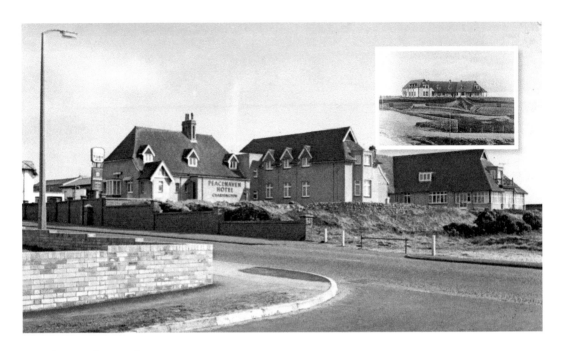

Peacehaven, the Hotel

To mark the establishment of Peacehaven as a community, Charles Neville opened Hotel Peacehaven on 10 October 1922. Many journalists were among the guests lavishly entertained in the marquee and some were later shown round the burgeoning estate. Attractive external features of the hotel were the sunken Italian garden, with its rockeries, walkways and fountain, and the charming tea pavilion. The hotel would go on to attract many guests from England and abroad over the next sixty-five years. Not far from where it stood, the Crown carvery (right) does brisk business today.

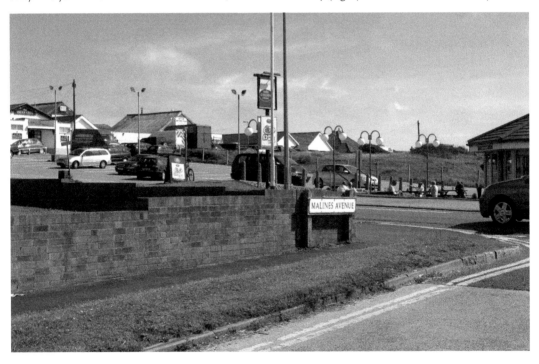

Telscombe Cliffs

Home to some 4,500 residents, Telscombe Cliffs developed to such an extent between the wars (becoming, in effect, a westward extension of Peacehaven) that it gained a parish council in 1929. In that year, an Italian cargo vessel, the *Nimbo*, ran aground on the foreshore, the entire crew being saved using a Breeches Buoy.

In 1974, Telscombe proper (which included the ancient inland village and East Saltdean) became a town, with a mayor.

The outfall installations, dating from 1879, are today being modernised as part of a major scheme extending from Brighton to Peacehaven and Friar's Bay near Newhaven.

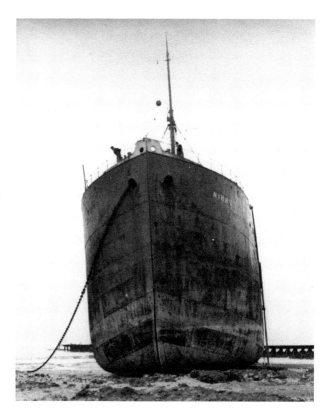

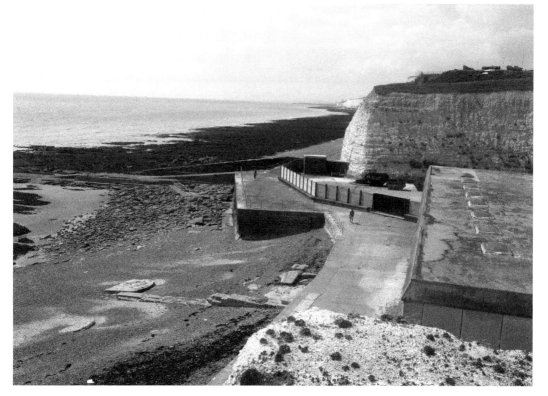

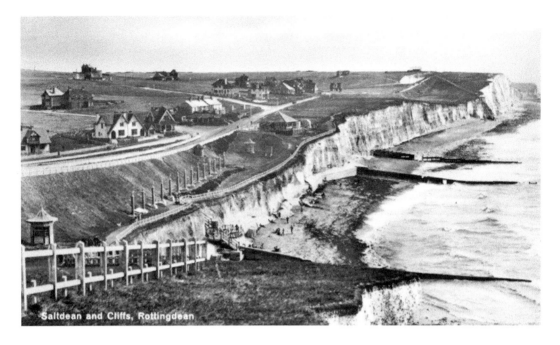

Saltdean and Cliffs, Rottingdean

Saltdean, a Salubrious Suburb

Saltdean, with its rugged cliffs and green hills and valleys, also owes its development as a residential area and resort to Charles Neville. Formerly only the row of coastguard cottages, set back from the coast road, stood at this location. Just to the east, the old drove road to Lewes, now known as Longridge Avenue, marks the 1,000-year-old division between the parishes of Telscombe and Rottingdean. It is at this point, too, that we leave East Sussex and enter the City of Brighton and Hove.

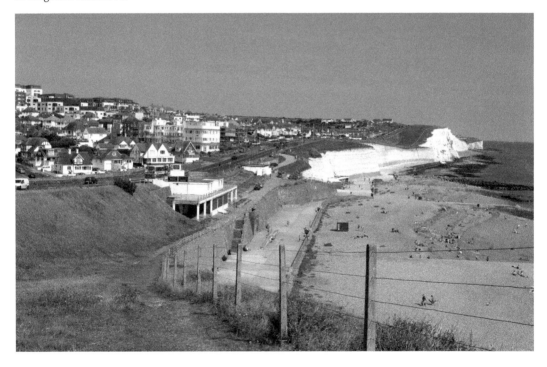

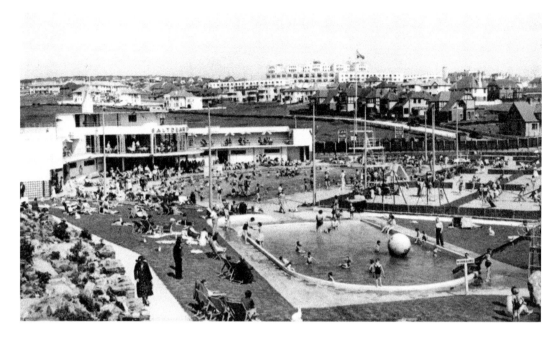

Saltdean, the Iconic Lido

The designer of Peacehaven's Meridian obelisk, Richard W. H. Jones, was the architect of two major leisure complexes in Saltdean: the Ocean Hotel, seen in the distance when newly opened in 1938, and the Lido, complete with children's pool and sand enclosures, dating from the same year. Jones also designed a number of apartment blocks for Neville's Saltdean Estate Company. After a chequered existence, the Lido has been the subject, since 2010, of a local campaign focusing on its protection from development and its management and operation by the community. Through the campaign's efforts, Grade II* status has been secured for the complex, making this the first lido in the country to have achieved such recognition.

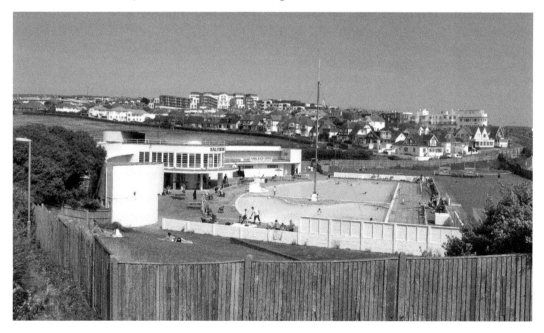

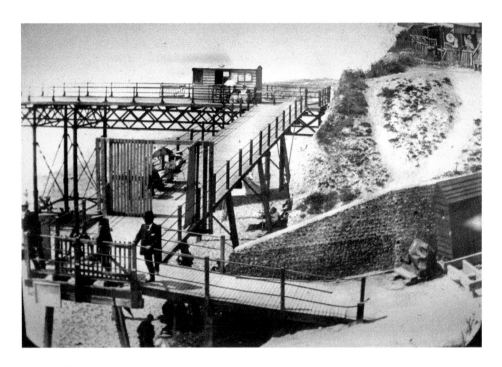

Rottingdean, Beach Approach

It would be hard to imagine a greater change in a location than that depicted in these two views of the area affording access to the beach in this historic village. The extremely rare – possibly unique – glass slide above reveals in detail how the head of the jetty was reached by passengers intending to travel to Kemp Town, Brighton, on the extraordinary seagoing car *Pioneer* on Magnus Volk's Brighton and Rottingdean Seashore Electric Railway. This operated from 1896 to 1901. The pier was demolished in 1910. The terrace area below is currently being developed as a venue for public performances and events.

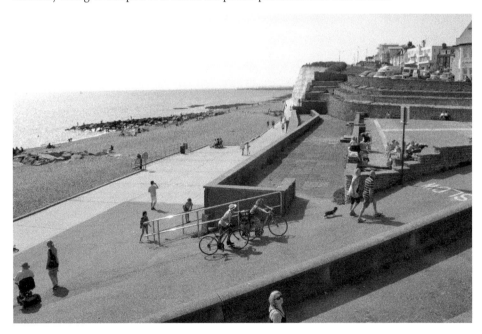

Rottingdean from the Rocks

These views clearly show the extent of change at the seaward end of the village. The rock breakwater was created in 1994/95, at which time the beach was recharged as part of the same coastal protection scheme.

On land, the White Horse Hotel (extreme left) was rebuilt in 1934. The construction of St Margaret's Flats (centre) followed – amid much local opposition – four years later. Highcliff Court (right) dates from 1967.

The early image provides an unusual and detailed view of the access ramp to the pier and of part of the pier itself.

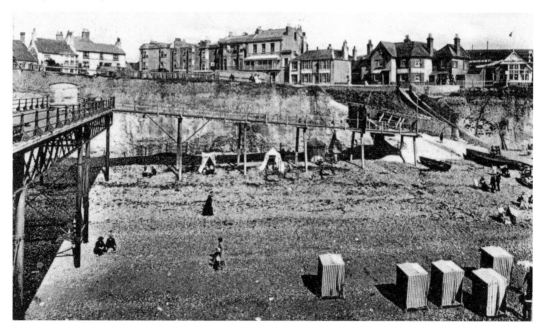

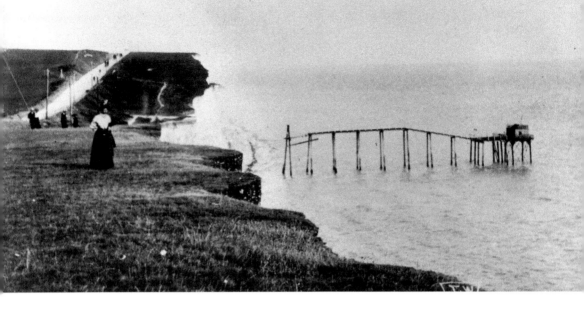

Ovingdean Cliffs and Jetty

Just west of Rottingdean is Ovingdean, the coastal portion of which historically lay within the former's parish as far as Black Rock, Brighton. Here, at the Gap, stood the Seashore Electric Railway jetty, which languished for fully nine years after the service was withdrawn; the foreshore section, however, appears to be absent in this image. Today, stone steps lead down at this point to the Undercliff Walk, the Brighton to Rottingdean section of which opened on 4 July 1933.

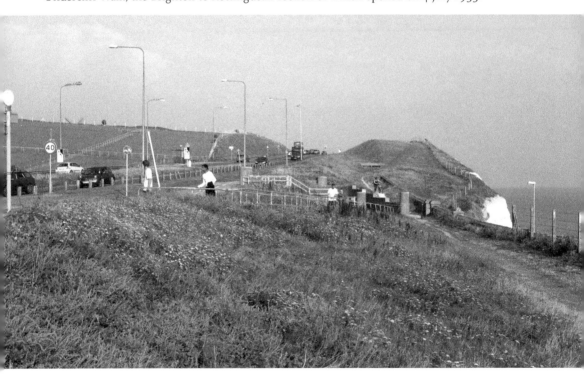

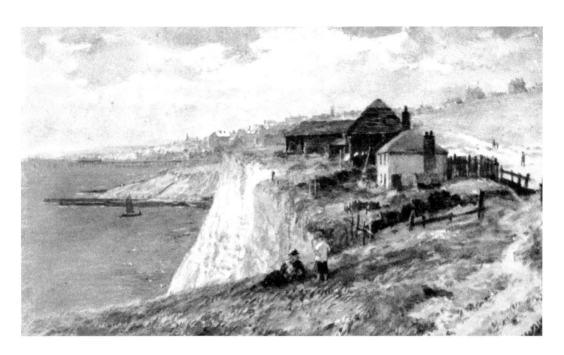

Roedean

The artist William Henry Borrow, who flourished in the period 1863–95, has left us a number of paintings of coastal Sussex. This postcard shows in colourful detail the buildings of Roedean Farm. Although perilously close to the cliff edge, they did not ultimately succumb to the sea, but were razed by the new landowner, Brighton Corporation, when the Rottingdean road was built beside them; it opened on 22 July 1932.

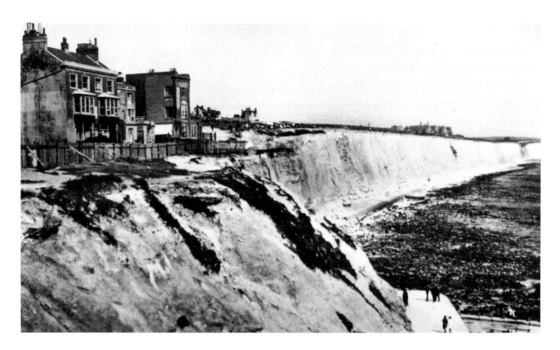

Black Rock, Brighton, Looking East

The three clifftop properties on Sea View Terrace, depicted on this postcard, were demolished between 1929 and 1932. Black Rock House (left) was the first to be pulled down and the Cliff Creamery (right) soon followed. The Abergavenny Arms in between them was razed in 1932 in connection with work on the new coast road referred to on the previous page. The modern photograph shows Marine Gate, constructed in 1937–39, housing development in Roedean and part of the extensive Marina complex. In both views, Roedean School may be seen in the distance.

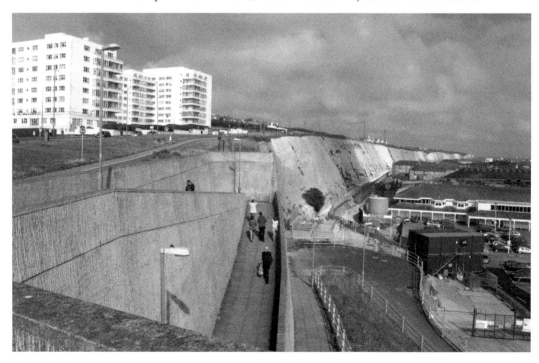

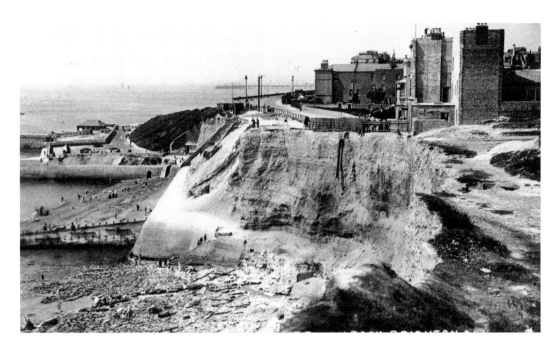

Black Rock, Brighton, Looking West

This exceptionally sharp photograph by Portsmouth postcard publisher J. Welch & Sons reveals the fragility of the cliffs at this location, with evidence of a landslip clearly visible. Posted on 1 July 1913, it also shows the eastern elevations of the Cliff Creamery, the bay windows of Black Rock House and, in the distance on the left, the Bungalow Station of Volk's Railway. The station was supplanted by Black Rock Swimming Pool, which opened in 1936. It closed in 1978 and its site is now desolate waste ground. The 1970s postcard below is a cheerful alternative to the depressing reality of the view west from this point today. *Inset:* the pool in its heyday.

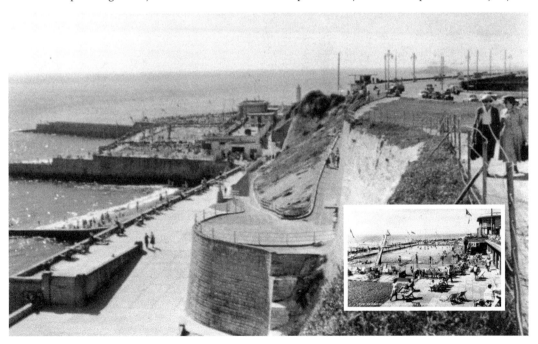

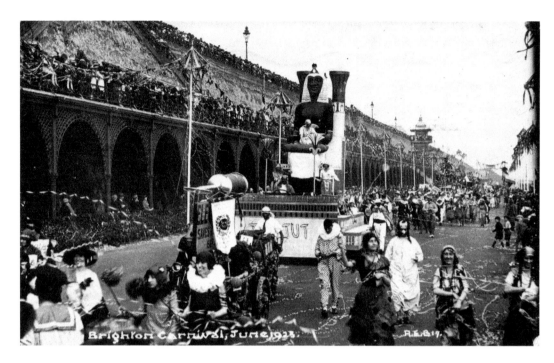

Brighton, on Madeira Drive

To boost Brighton's tourist trade in the early 1920s, carnivals were held, inspired by those in Nice. A major contribution to the design, building and manning of floats was made by the town's School of Art and its tutors and students. Their creations were of such a standard that they attracted the attention of the national press in both 1922 and 1923.

The first Brighton Gay Pride march took place in 1973, although it was not repeated until 1991. It has now become an annual extravaganza. Here we see an emergency services contingent setting off on 13 August 2011.

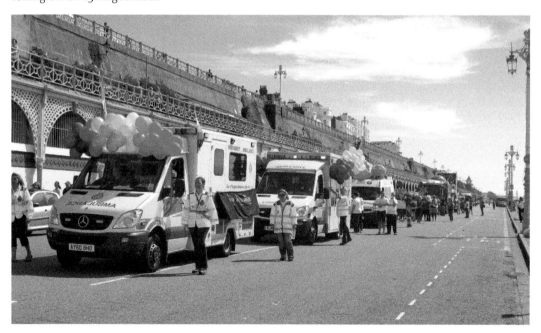

Brighton, the Fish Market

This splendid postcard by French publisher LL, whom we have already met, was posted in September 1911. The fish market stood, from time immemorial, on the beach below the low cliffs near the end of East Street. When the King's Road Arches were formed in the 1880s, Nos 216–224 (below today's Thistle Hotel) were allocated for the market, with a hard provided in front for stalls. It was closed by the Council on hygiene grounds in 1960 and moved to Circus Street. The arches have since been used for leisure and retail purposes.

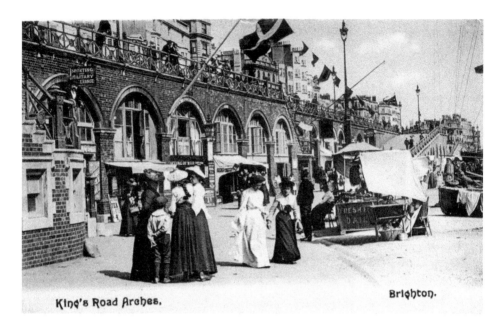

King's Road Arches. Brighton.

Brighton, King's Road Arches

Of interest in both the genteel image by Brighton's Mezzotint Company above and the busy photograph taken below on 5 August 2011 is the Fortune of War pub. On 14 June 2009, it was described thus in the *Observer*: '... an upturned wooden keel nestled into the arches of Brighton's seafront. Established in 1882, like a dry-docked warship it has fought off an Armada of all manner of trendy clubs and bars and remains the one true pub on the seafront. Oddly, the nautical paraphernalia – the rope-railed stairwell, the below-deck interior and the twin wooden hulls of the upstairs bar – never feels overdone.'

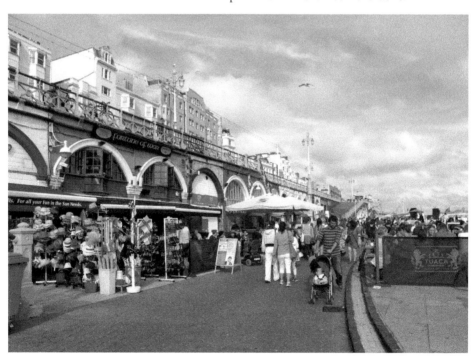

Brighton, the West Pier in Youth and Death

Contrasting with the splendid study below by contributor Stuart Herbert dating from February 2008 is a post-1874 *carte de visite* image by Brighton photographer Ebenezer Woodcock (1824–1889) of the pier in its early form. Woodcock set up his photography and stationery business at No. 9 North Street Quadrant, Brighton, in around 1866, the year in which the structure was built. He remained in business in the town until about 1887.

As at Eastbourne, the pier was designed by Eugenius Birch. Weakened in part by a huge storm in 2002, it was sadly destroyed by two arson attacks in 2003.

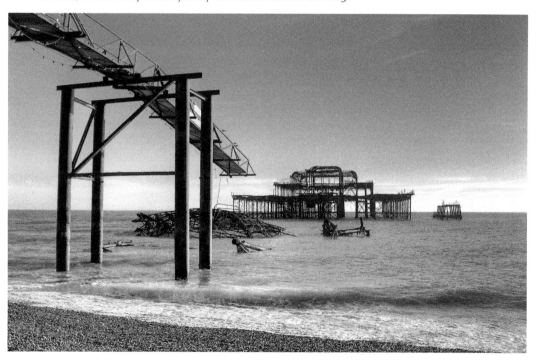

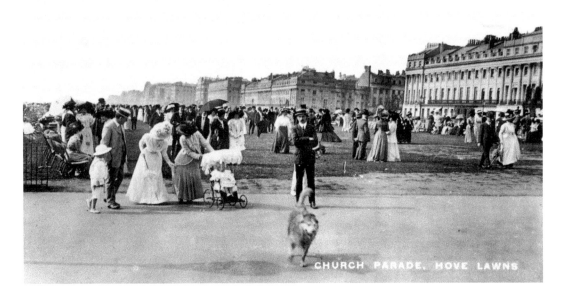

CHURCH PARADE, HOVE LAWNS

Hove, the Church Parade

The Sunday morning post-church parades were a feature of fashionable Edwardian life, as we saw in Eastbourne (page 20). The venue in Hove was Brunswick Lawns. Opposite is elegant Brunswick Terrace, the foundations of which were laid in 1824.

A sharp contrast in attire is presented in the contemporary photograph below, also taken on a Sunday, featuring visitors to the attractions on the lawns during the 15th Annual Paddle Round the Pier Weekend at the beginning of July 2011.

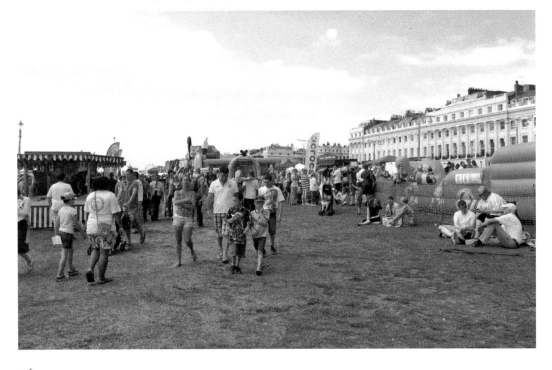

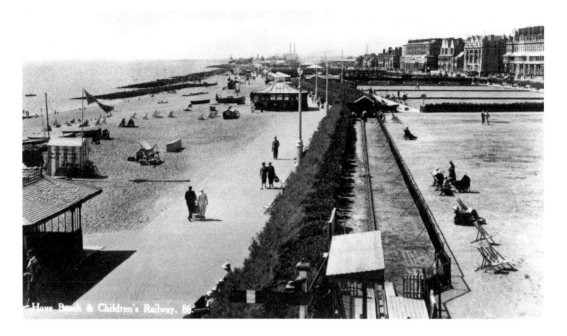

Hove, a Lost Railway

A rare view of the miniature railway, which used to operate on No. 1 Western Lawns. It opened in 1928 and survived until 1939. Owned by a Mr F. Russell Hutchinson of Surbiton, who built everything himself, the railway ran each summer, with the takings being donated to the Southern Railway's servants' orphanage.

A feature on the same site in recent years has been the annual visit by Zippo's Circus. Here, on 19 August 2011, an afternoon performance has just finished and the homeward rush has begun.

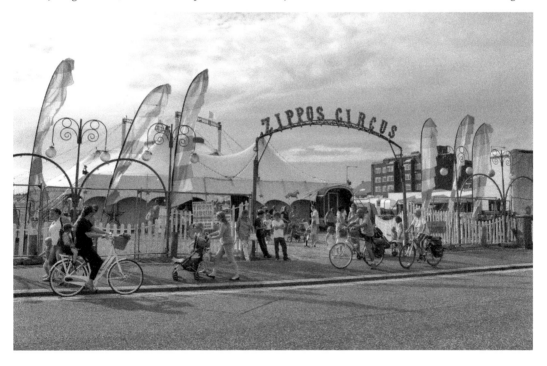

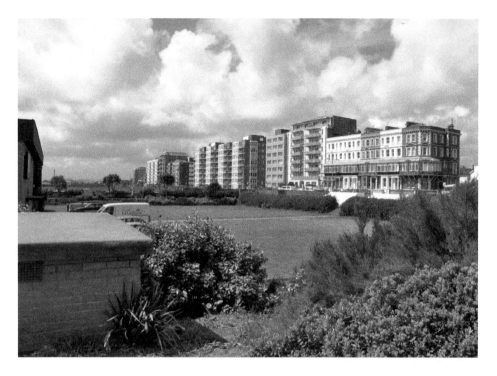

Hove, the Silent Lawns

In 1911, a bandstand was erected south of Walsingham and Carlisle Roads. During that first season, the band of the 4th (Royal Irish) Dragoon Guards gave twenty-seven concerts. A revolving glazed screen was fitted to the structure twelve years later. In the image below, showing a female vocalist entertaining the crowd against the backdrop of Walsingham Terrace, may be seen the circle of concrete which on occasion served as a dance floor.

The bandstand was demolished in 1965 – yet the one in Brighton was restored some years ago at considerable cost.

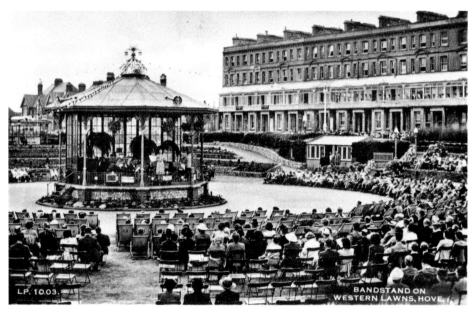

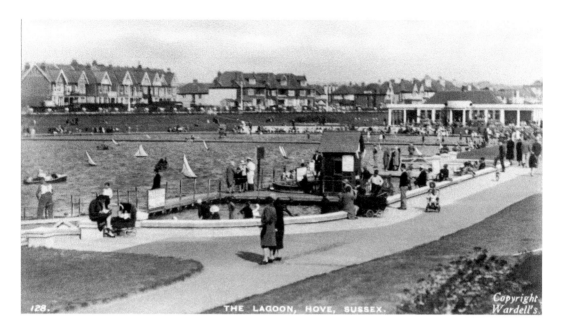

THE LAGOON, HOVE, SUSSEX.

128.

Copyright
Wardell's

Hove, the Lagoon

It was in 1930 that the lagoon site – in times past a tidal reach of the River Adur – was developed, complete with shrubs, flowerbeds, a small putting green, and a children's playground, although initial work had been carried out in 1921–23, providing employment for out-of-work men. In 1944, the lagoon was used as a training ground in the run-up to D-Day, with tanks that had been made watertight being tested at night.

Lagoon Watersports (originally known as Sailboarding 80s), whose new centre opened in 1994, has been based here since the mid-1980s.

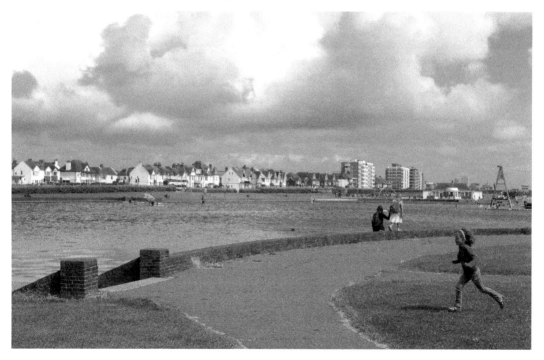

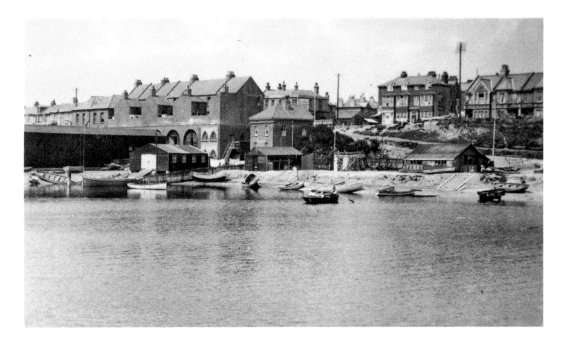

Portslade-by-Sea, the Ferry

Although this postcard (on the reverse of which is written 'January 16th – 20th 1931') is captioned 'The Ferry, Portslade', we are still (just) in Hove. Boundary Road and Station Road lie just behind the telegraph pole that is almost in the middle of the picture. The rowboat ferry, one of a number along this stretch to Southwick, is seen conveying three passengers across the canal but could carry six. It operated until the 1960s.

The recent photograph shows the preserved *Challenge*, built in 1931, the last surviving example of a large purpose-built, Thames ship-handling tug and one of the Dunkirk 'little ships'.

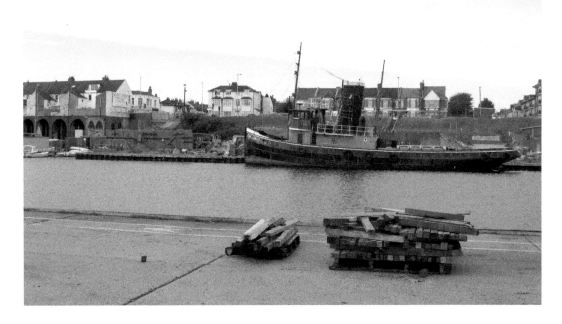

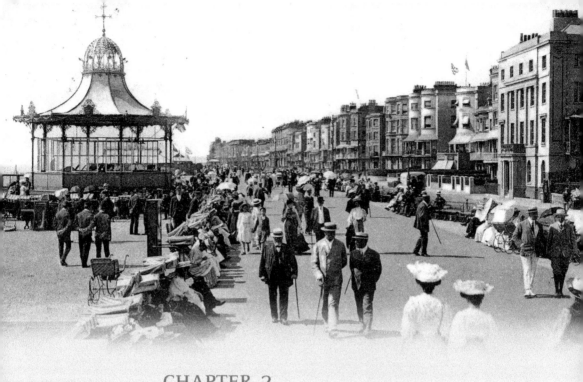

CHAPTER 2

West Sussex

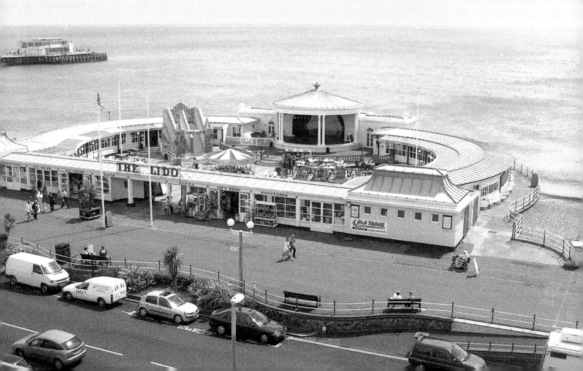

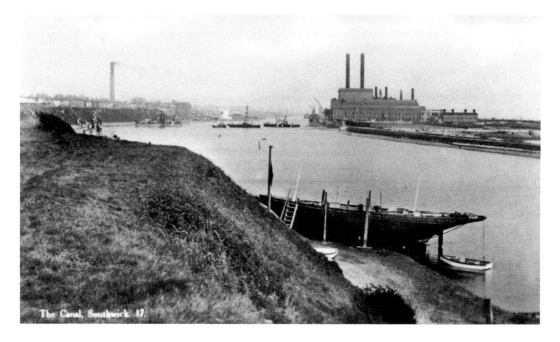

The Canal, Southwick. 17

Southwick, the Canal, Looking East

Undergoing a refit between 1914 and 1918 is, probably, the *Six Sisters*, one of eight such vessels. Beyond the bank is Bank House, where several families lived – fishermen, oyster merchants or carters depending on the generation. Anchored across the canal as a deterrent to seaplanes, over the spot where the cable tunnel from the power station ran across to the shore, are, from left to right, a dredger, a safety boat, a pile driver and a barge. The chimney on the left is that of Flinn's, the dyer's and cleaner's in Fishersgate. Opposite is Brighton A power station (operational 1906–76). The recent picture was taken from near the Prince Philip Lock.

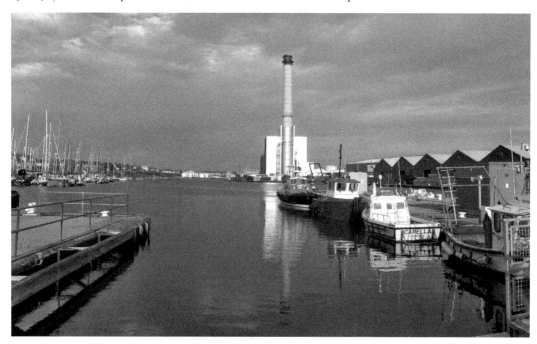

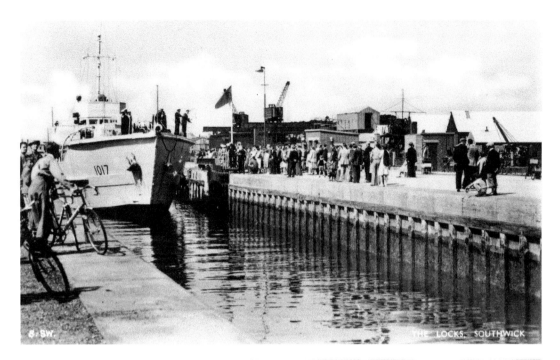

Southwick, the Prince Philip Lock

The first lock in Southwick was built in 1850. The Southwick Ship Canal, branching off from the estuary of the River Adur near Hove, was opened five years later to provide tide-free docking facilities to the port of Shoreham. It is 1¾ miles in length.

The next lock to be opened was the Prince George Lock in 1933, followed by the Prince Philip Lock alongside it in 1958. The opening day is recorded above, while the contemporary view shows the British oil products tanker, the *Galway Fisher* of 1997, waiting to enter the enclosed dock on 28 July 2011.

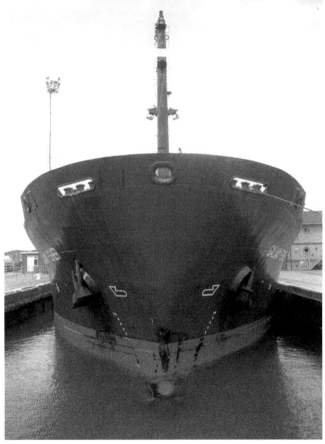

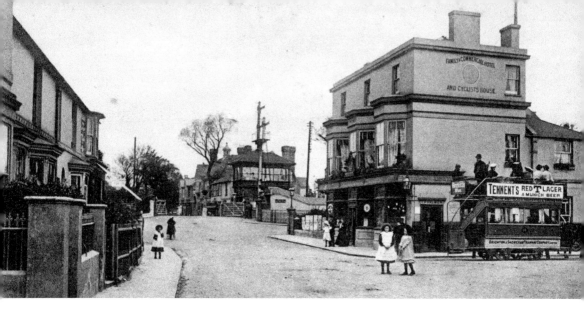

Shoreham-by-Sea, Near the Station

Behind Thomas Palmer's Burrell Arms public house and hotel at the junction between Brunswick Road (ahead) and Ham Road (right) stands Shoreham's railway station, one of the earliest to be built in southern England, having opened on 11 May 1840.

The horse bus service on the right was operated by the Brighton and Shoreham Tramway Company, whose tramway, the first in the wider Brighton area, opened on 3 July 1884. Horse traction, as seen here, was used from 1893 until 1913.

The Burrell Arms has today become the Brio Italian restaurant and pizzeria, and shops have replaced the houses in Brunswick Road.

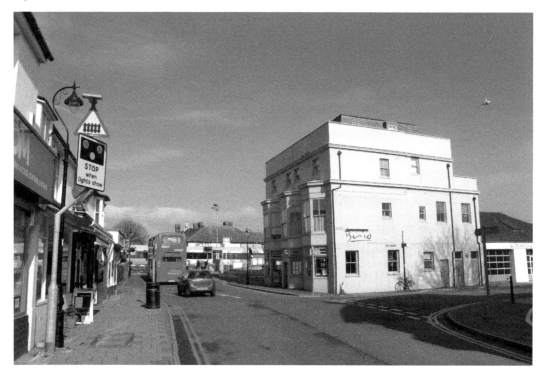

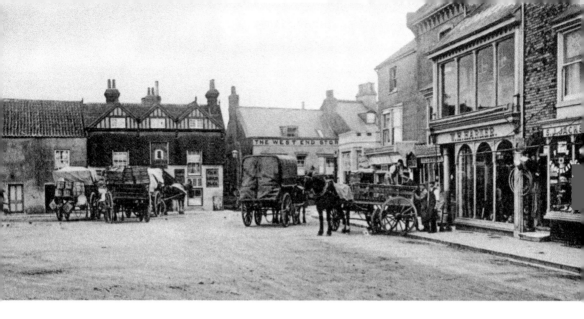

Shoreham-by-Sea, High Street

Remarkable changes have taken place at the western end of Shoreham High Street, where the February sun has brought scooter riders out in force. A busy roundabout now filters traffic from the old Shoreham Road (unseen, on the right) between the High Street and the A259 over Norfolk Bridge off to the left. William Henry Harker, ironmonger and seedsman, had a good eye for business, displaying wares in full view on the first floor of his premises.

The Tudor-gabled King's Head of 1715 closed in 1983 and the Ropetackle Centre arts and entertainment venue (its future uncertain) now occupies its site.

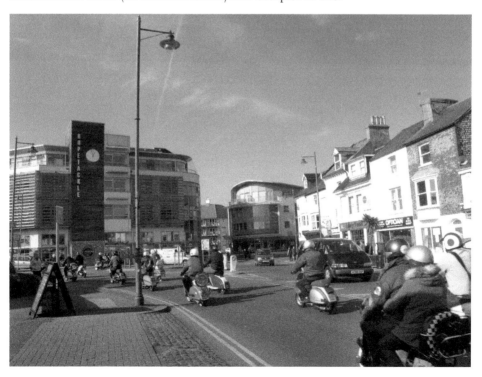

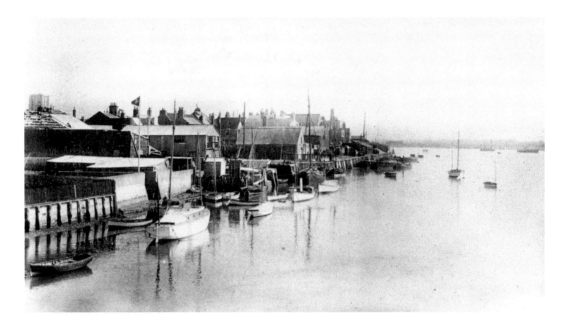

Shoreham-by-Sea, from Norfolk Bridge

The views were taken from the Norfolk Bridge over the Adur. Originally built as a girder bridge by the Duke of Norfolk in 1832, it was replaced by a suspension bridge in 1923, this being replaced in turn by the present structure in 1987. On the extreme left in the modern view stands an extension of the toll-house of 1833, from which toll collection ceased in 1927. Some of the riverside commercial/light industry premises in the early view have been supplanted by the Norfolk House government office block, vacated and awaiting development, and, behind it, the apartments of Riverside House.

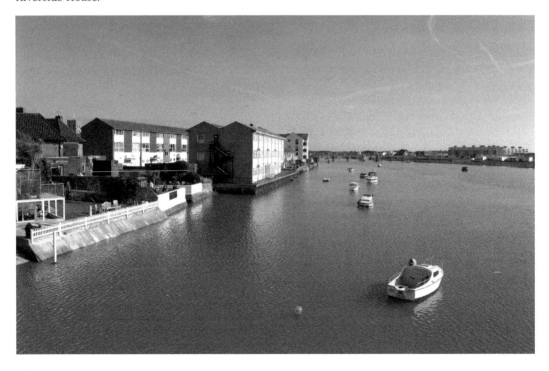

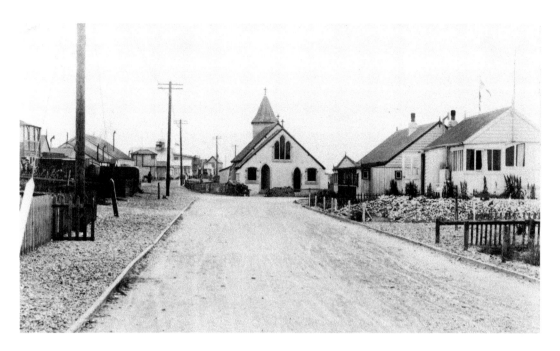

Shoreham-by-Sea, Bungalow Town and Shoreham Beach (1)

Built on a 4-acre shingle spit extending westwards from the mouth of the Adur, Bungalow Town's origin may be traced to structures first erected in the late 1880s and the 1890s. The beach became a colony for film, theatre and music stars and, between 1915 and 1922 boasted a fine studio of its own. The haphazard and makeshift dwellings were often constructed around redundant railway carriages. Mains services were initially non-existent and water was 'imported' from the mainland.

The Church of the Good Shepherd, built and dedicated in 1913, is the only building of substance to have survived.

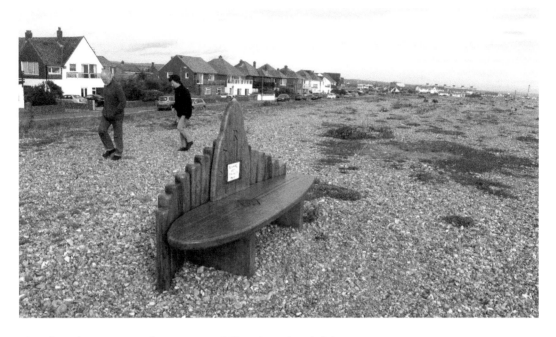

Shoreham-by-Sea, Bungalow Town and Shoreham Beach (2)

A bench in memory of tragic student Mark Dare was put up on Shoreham Beach near the southern end of Mardyke on 17 November 2007. The tribute to the 21-year-old, who had died in a skydiving accident in France, was organised and funded by his friends from the Waterside Inn in Ferry Road.

The background to the picture above illustrates how substantial the residences are today in the Shoreham Beach area. Bungalow Town, which officially became part of Shoreham-by-Sea in 1910, was largely cleared in 1939, when some 700 of the dwellings were demolished as an anti-invasion measure.

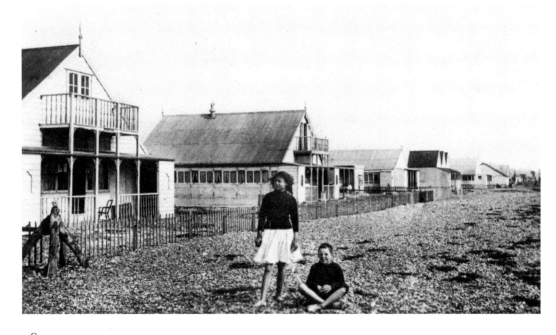

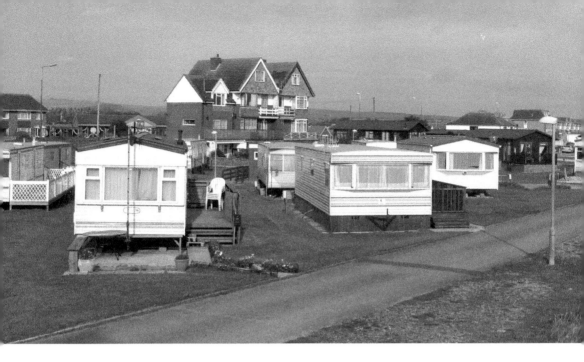

Lancing, Golden Sands (1)

Shoreham's western neighbour, Lancing, also contained scores of the quirky, often fragile, homes of Bungalow Town. A goodly number were, of course, owned or rented by holidaymakers, who in later years stayed in mobile or static caravans. Postcard publisher Alfred Wardell has admirably captured for us the scene in the early 1950s but his caption refers to the Golden Beach (instead of Sands) Caravan Camp. In July 2011, Golden Sands was renamed Beach Park.

The gabled property in the background is today Mermaid Lodge, a residential care home for young adults.

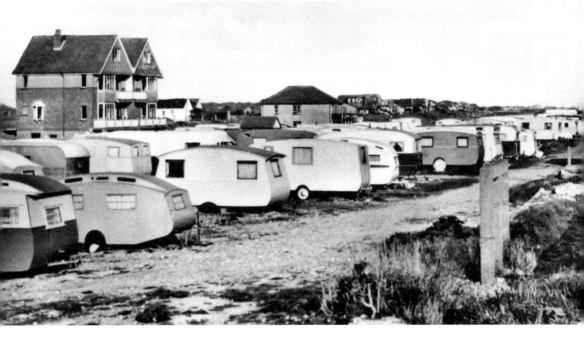

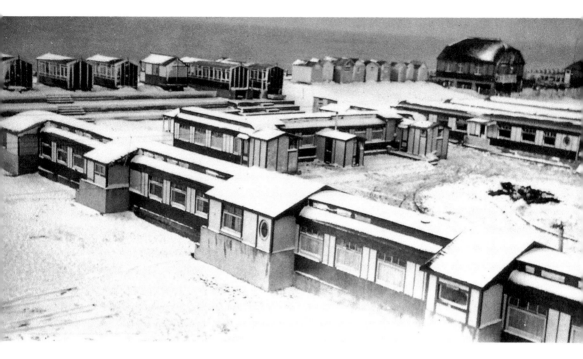

Lancing, Golden Sands (2)

Jon Spence, the contributor of the above image (thought to date from the early 1930s), has recorded that a relative by marriage, Stanley Howard Winton (1882–1923), created the Golden Sands Holiday Park using redundant Pullman cars. These would have been obtained from the Southern Railway's wagon and carriage works located near the town. The works had opened in January 1912 and operated until 1965. On today's Beach Park site, the appearance of the homes recalls in some ways that of the railway carriages of the past.

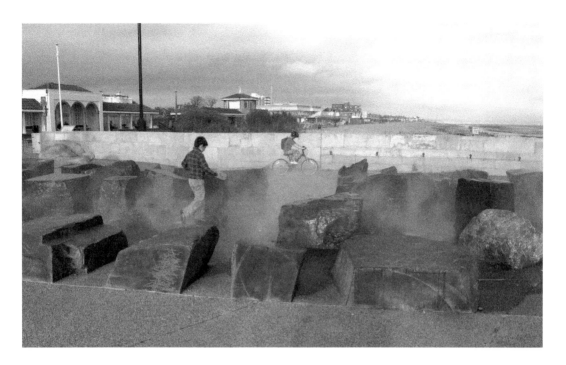

Worthing, Splash Point

Much has changed over the last century at Splash Point in Marine Parade, Worthing. The view on the postcard, sent in July 1915, shows the splendid eastward view to be had from this location. On the left, the wall and trees mark the southern boundary of the grounds of Beach House, a Grade II* listed Regency villa built in 1820.

Today, among the informally placed engraved boulders near a grove of tamarisk trees, rainbow mists are created by the jets built into them as a feature. The young lad is clearly enjoying them.

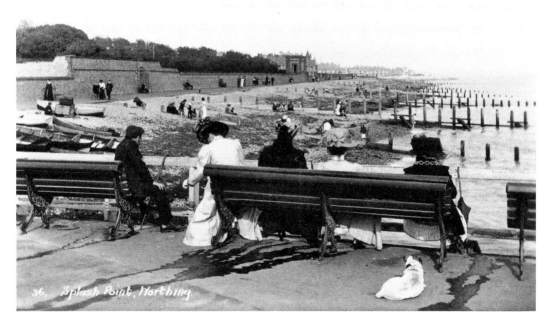

36. Splash Point, Worthing.

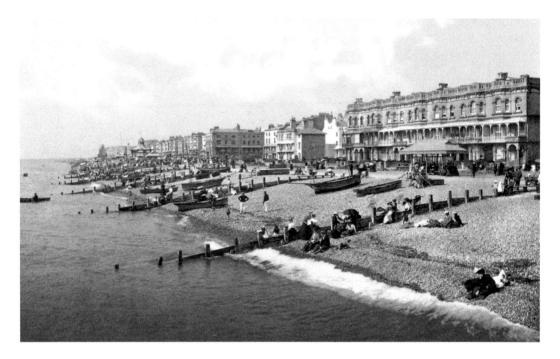

Worthing, Westward View, 1890s

Worthing's transition from a small mackerel fishing hamlet to an elegant watering-place is colourfully revealed in this Victorian Photochrom image taken from the town's pier, opened in 1862. The Esplanade, spanning half a mile from Warwick Road to West Buildings, was built in 1821 and renamed Marine Parade in 1865 when it was extended to Heene Road. Part of the balustraded terrace is now obscured by the Denton bar and dining room of 1955. In the distance on the left, where the lido now stands, may be seen the 'birdcage' bandstand erected in 1897. Wooden groynes continue to help prevent erosion and the longshore drift of beach material to the east.

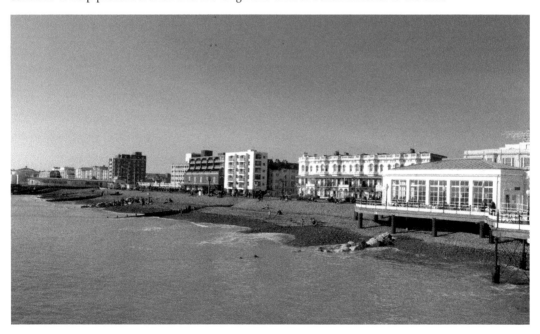

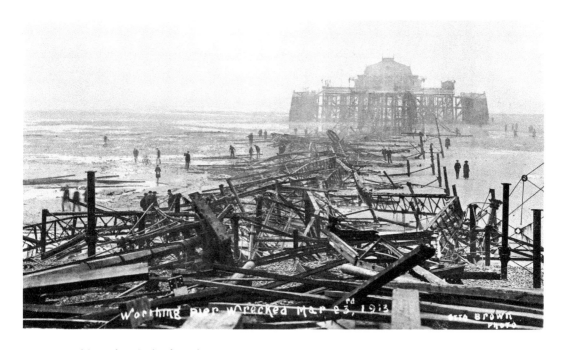

Worthing, the Pier's Changing Fortunes

Shortly after midnight on the night of 22/23 March 1913, 80 mph winds caused a tidal wave which wrecked Worthing's 1862 pier; so massive were the seas that the structure was cut into two, with the Southern Pavilion left detached from the flattened and twisted northern section. Thousands of tourists flocked to view the wreckage and also the Pavilion, then dubbed 'Easter Island'. The pier was repaired and re-opened on 29 May 1914. Named 'Pier of the Year' in 2006, it stands secure from the sea in October 2011 in a fine study by contributor Ben Daniels.

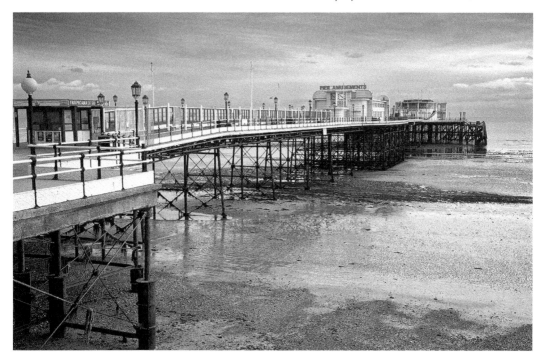

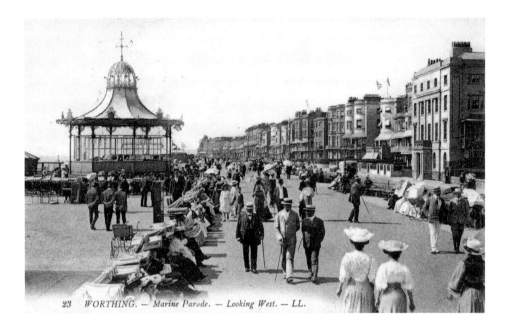

23 WORTHING. — Marine Parade. — Looking West. — LL.

Worthing, the Bandstand and Lido

This splendid animated scene on a postcard by publisher LL shows the 1897 bandstand on the left and the long-standing Marlborough House Boarding Establishment, whose place has been taken by an unsightly but necessary multi-storey car park, on the right.

The bandstand was demolished in 1925 and replaced by the Band Enclosure, later renamed the Lido. The present domed roof replaced the original canopy over the stage four years later. With interest in band music declining, the Lido operated from 1957 to 1988 as an unheated swimming pool with purified seawater. In the following winter, the pool was built over and the present-day Family Entertainment Centre was developed on the site.

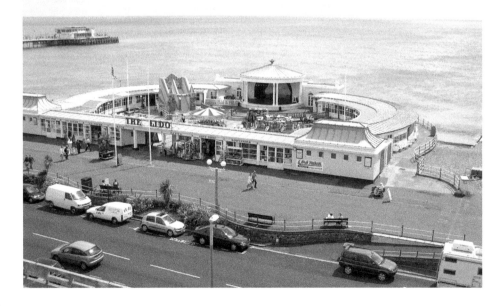

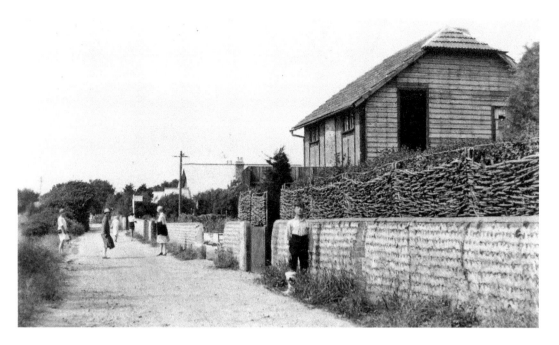

Goring-by-Sea

Part of the Borough of Worthing since 1929, Goring-by-Sea boasts a long shingle beach. Sea Lane, seen above in probably the late 1920s, runs south from the A259/Goring Road. The building depicted was by 1929 'The Shop' and by 1930 the Sea Place Café. By July 1939 and until the late 1950s, it was being run as a general shop and survived as a grocer's until at least 1975 and probably much later. It has recently been demolished to make way for new housing called Waterfront Mews being built by Kier Group plc.

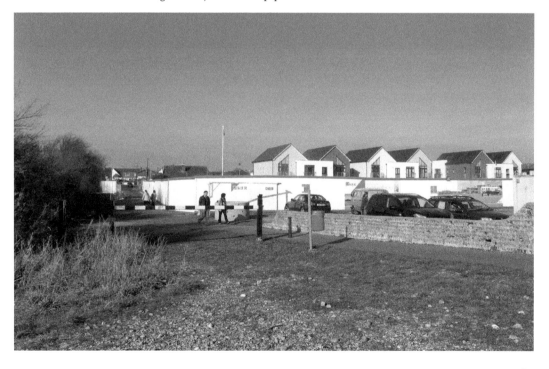

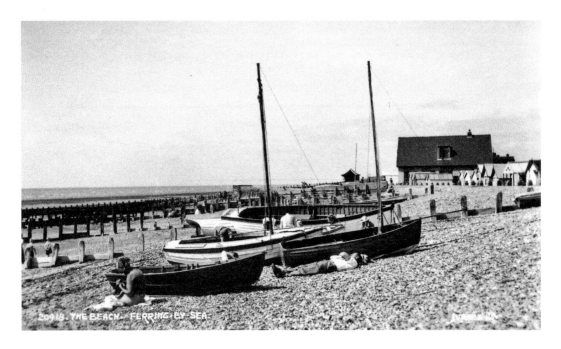

Ferring

Three miles west of Worthing, and within its built-up area, lies the ancient village of Ferring. In common with many of the coastal communities we visit in this volume, it has the A259 as its main thoroughfare and underwent more demographic change between the wars than at any previous time in its history. The beach area, however, remained free from any major development. In both images we see the Blue Bird Café, built in the early 1930s. Named Martin's Retreat for a time, it was again renamed as the Lemon Tree Café in 1993 when the sea defences had been improved. It is now the Blue Bird Café once more.

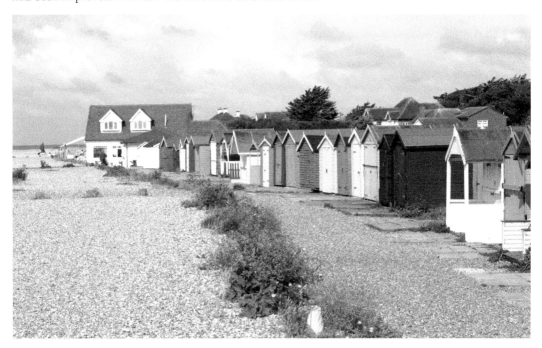

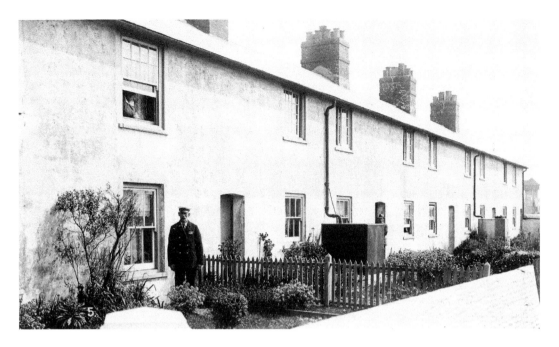

East Preston, Angmering-on-Sea (1)

Angmering-on-Sea, far from being part of Angmering proper, which lies some two miles north of the sea, was the name given by builder and developer William Hollis in 1916 to South Strand on the coast. The estate was built piecemeal by its residents and its eventual limits were only reached in 1927. Like East and West Kingston, Kingston Gorse and The Willowhayne, it is part of the parish of East Preston. Today the old Coastguard Cottages are desirable dwellings. They were one of the few buildings in the area in 1907 when the first development by the sea took place and would undergo some alteration in the 1920s, as is evident below

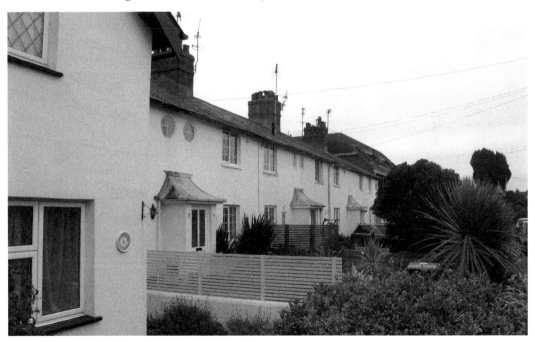

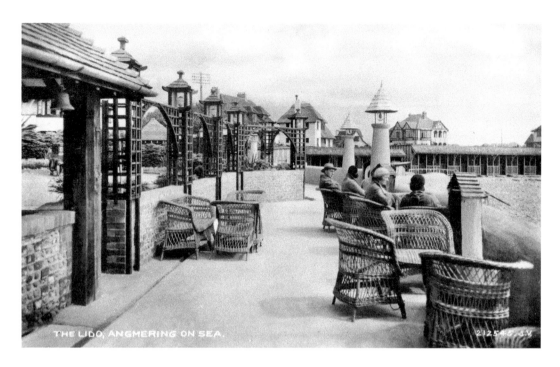

THE LIDO, ANGMERING ON SEA.

East Preston, Angmering-on-Sea (2)

In November 1911, Hollis purchased a section of South Strand on which he built his first house, the Bungalow, as his country retreat. Public tennis courts for the estate were laid out just east of his property two years later when he acquired two seaside plots, extending right through to the border of Kingston and the eventual site of the Lido. This had a tea room, a terrace overlooking the sea, an upper tea deck and a dance lounge, plus a range of bathing cabins on the beach below. Both the Lido and promenade were sold by Hollis for £4,000 to a Mr F. Adams of High Wycombe in September 1932.

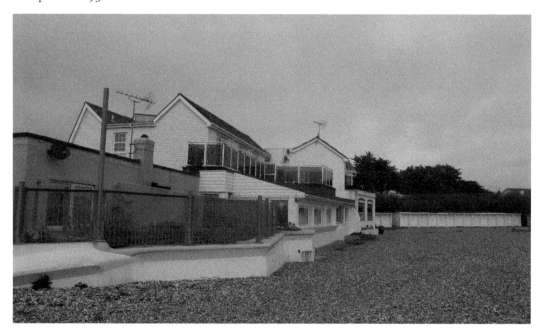

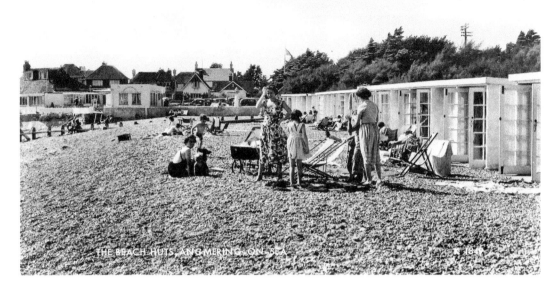

East Preston, Angmering-on-Sea (3)

The Blue Peter club was set up on part of the site of the Lido shortly after it was sold. It may be seen in the distance in this 1950s view of the beach and bathing huts when operating as a café at this prime location. Its present day sucessor is the Ristorante Bella Vista, behind which, on the left, can be seen Angmering-on-Sea Beach House, the twin pitched roofs of which feature on the previous page. Currently being refurbished, the building occupies much of the Lido site.

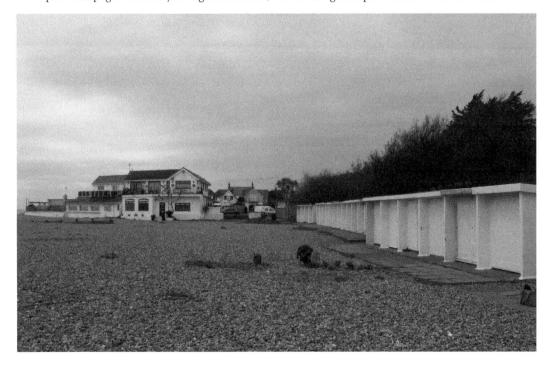

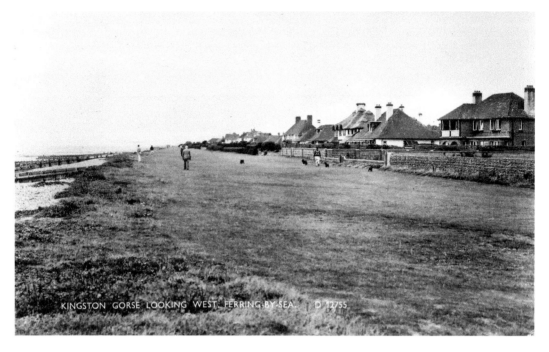

KINGSTON GORSE LOOKING WEST, FERRING-BY-SEA. D 12755

East Preston, Kingston Gorse

A feature of the West Sussex coast is the greensward abutting the foreshore, with substantial properties adjacent. The above postcard by Shoesmith & Etheridge of Hastings, posted on 3 September 1961, portrays just such a scene. The recent image by contributor Andy McMenemy, taken from a different standpoint, reveals how popular the greensward continues to be with dog-walkers and their charges.

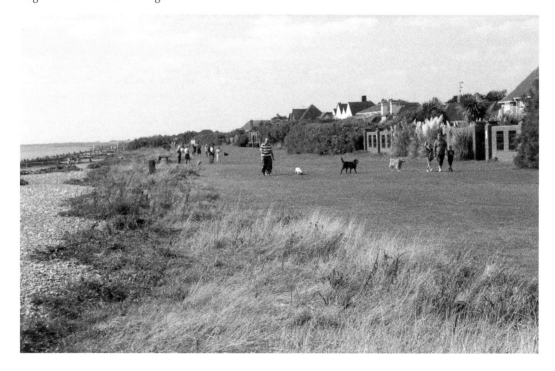

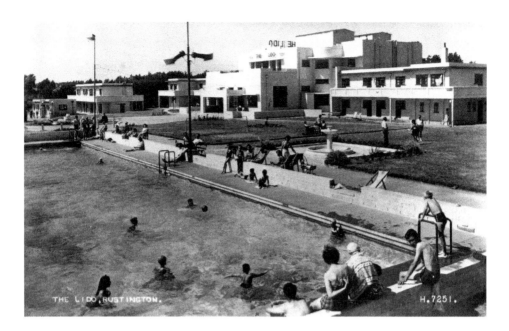

Rustington, the Lido

The Lido complex, Mallon Dene, consisting of an outdoor swimming pool, tennis courts, and other leisure facilities, was built in 1936 under the auspices of the WTA (Workers' Travel Association), a non-profitmaking organisation set up in 1921 to promote tourism at home and abroad. The 'Mallon' name commemorated a founder member of the association, James Joseph Mallon (1875–1961), known as Jimmy, Warden of Toynbee Hall. By 1960, the body had funds of over £2 million, eighteen hotels, guest houses and holiday centres of its own. Six years later it chnaged its name to Galleon Travel.

The Lido was a popular venue but fell victim to 'development', being demolished in 1967/68 to make way for the Mallon Dene Estate. The Broadmark Hotel was knocked down in 1984 and replaced by the Broadmark Beach flats.

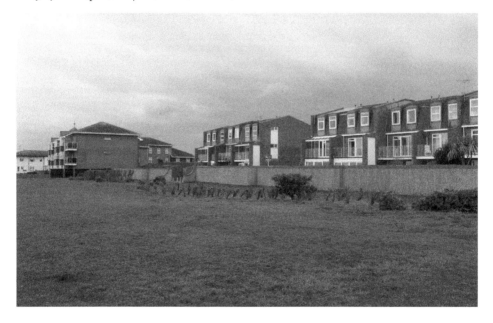

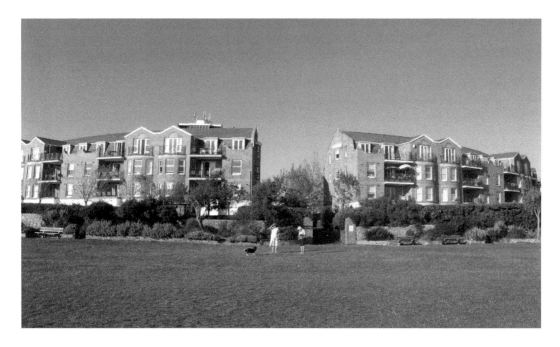

Littlehampton, Beach Crescent and the Beach Hotel

On the River Arun lies Littlehampton, a town with a long history as a fishing and trading port. It developed as a bathing resort soon after 1800 and has remained popular with tourists and visitors to this day. Here, separated from the beach by the Green, formerly the Common, we see Beach Crescent, a development of flats and houses erected following the demolition in 1993 of the imposing Beach Hotel. The hotel was put up in the early 1890s. Its features included rustic first floor verandas and a long, glazed conservatory. Parts of its outer garden wall have survived (see above). The hotel replaced a predecessor with the same name which dated from 1775.

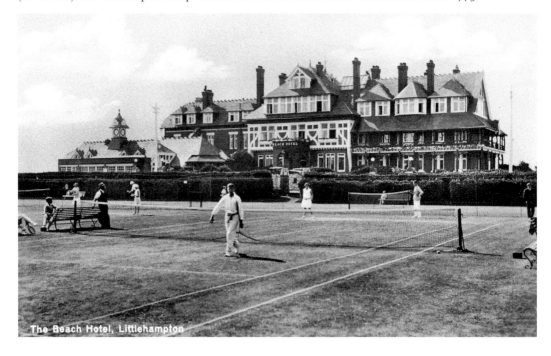

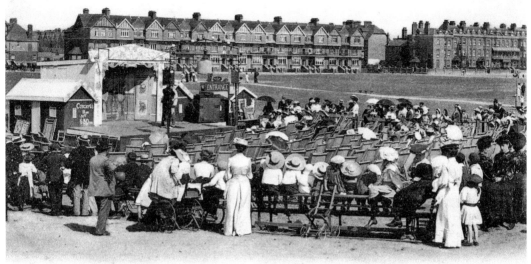

18 LITTLEHAMPTON. — On the Common. — LL.

Littlehampton, on the Common

There has been remarkably little change at this location just west of Beach Crescent between the time the atmospheric LL postcard above was produced and the unseasonably warm day of 2 October 2011. The entertainment on the Common, in probably 1908, is being provided by Harry Joseph and his troupe and is certainly holding the attention of the youngsters seated in the foreground. The houses in the background are on South Terrace between Beach Road (left) and Fitzalan Road (right).

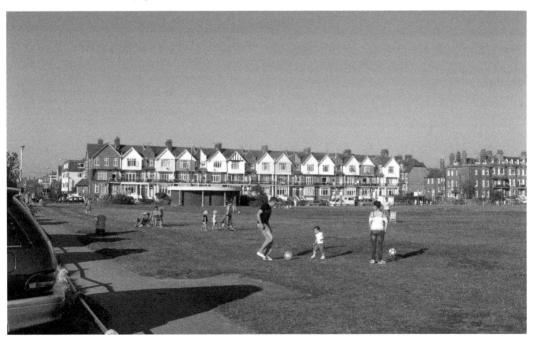

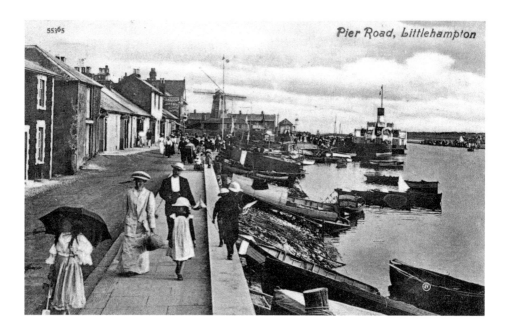

55365

Littlehampton, Pier Road, Looking South

The history of Littlehampton as a trading port can be traced back to the eleventh century when it prospered by importing limestone for building from Caen in Normandy. The many small boats moored near the riverside wall are evidence of the small-scale fishing that took place in Edwardian times. Alongside, the paddle steamer *Worthing Belle* is taking on passengers. Today the river bustles with pleasure craft, many of them with berths in the marina further upstream. The Arun windmill of 1831 in the distance worked until 1913 and was removed in 1931, while the Nelson Hotel, built as the Victory Inn in around 1830, is still very much in business.

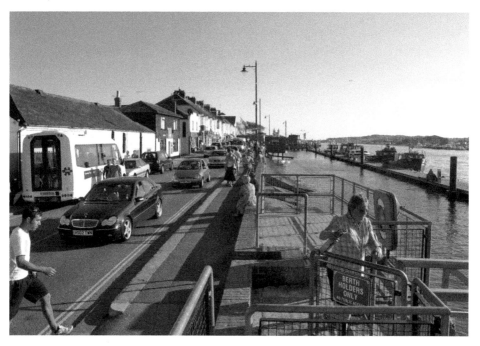

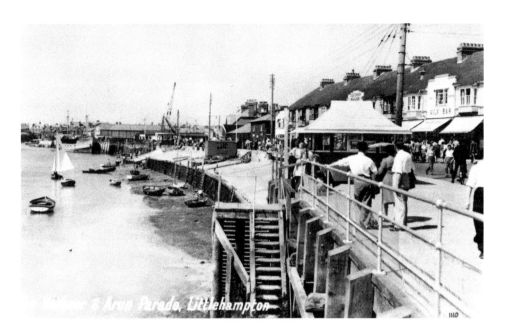

Littlehampton, Pier Road, Looking North

Although 'Arun Parade' is in the caption to this postcard, posted in 1949, we are firmly in Pier Road, with the Parade some way south behind the camera. All the present-day pictures of Littlehampton date from the extraordinarily summery Sunday of 2 October 2011, when the riverside businesses were doing a roaring trade and the beaches were packed. From the Nelson Steps, seen here, passengers were boarding 'Action Boat' craft (notice the banner), new to the harbour from 2 April 2011 and offering 'the ultimate powerboat experience' plus trips to Brighton Marina, Chichester Harbour and the Isle of Wight.

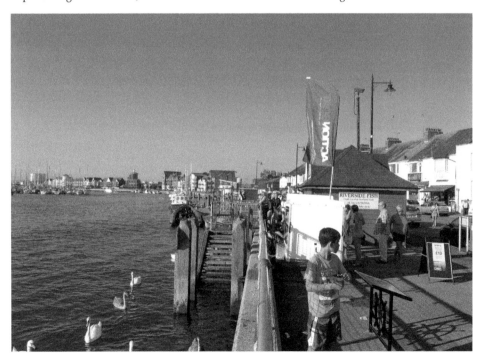

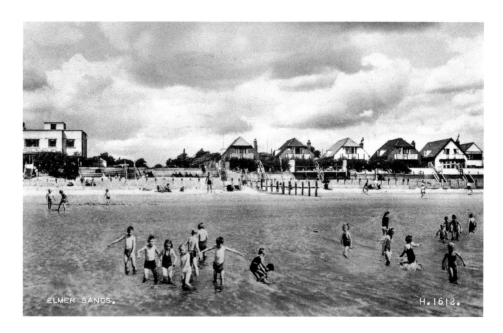

Elmer Sands

Adjacent to Middleton-on-Sea, within whose parish it lies, Elmer is part of the Bognor Regis conurbation. The Elmer Sands Estate was started in around 1928 but was flooded three years later when the sea banks were breached. A sea defence association was therefore formed and a wave screen subsequently erected. A holiday centre was established here in the early 1930s which lasted until the 1990s, when it was converted into flats and renamed Elmer Court. The sender of the above postcard, writing on 8 September 1955, reported 'The children love it here and the beach is quite quiet.'

Below, three of the author's grand-daughters enjoy the sands.

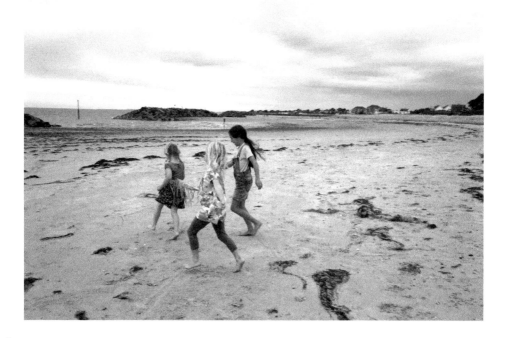

Middleton-on-Sea, the Sussex Coast Country Club

Middleton-on-Sea, with its safe, sandy beaches, developed as a resort after 1920. A major attraction was the 'New City', opened in 1922 by Sir Walter Blount, Bt. in the former seaplane factory south of the church. By 1934, the centre had become Southdean Hotel and Sports Club. After 1945, the site changed hands several times, being variously known as Southdean Holiday Camp, the Sussex Coast Country Club (as in the above postcard sent in 1978) and the Sussex Coast Holiday Centre. Shearings owned the complex for one season then closed it in 1995. It was subsequently demolished and replaced by the gated estate named Saxon Beach. The present-day picture was taken from Thompson Road, facing North East.

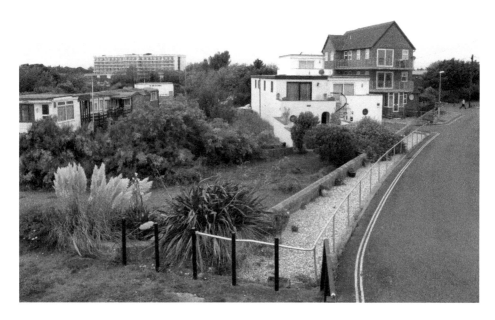

Felpham Dwellings

Between Middleton and Bognor lies Felpham (often pronounced 'Felfam' locally), whose most famous resident was the poet, painter and mystic, William Blake. In one verse he wrote 'Away to sweet Felpham for heaven is there'. The ancient village, with its medieval church, cottages, trees and flint walls, is but a short walk away from the beach, bordered by two greens and colourful beach huts.

The homes depicted above left, at the seaward end of Sea Road, retain the individuality of the characterful dwellings pictured below, dating from early last century and erected on stilts as protection against flooding.

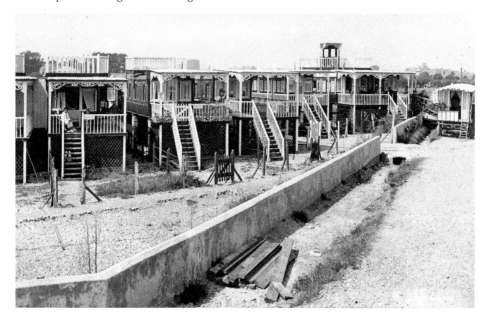

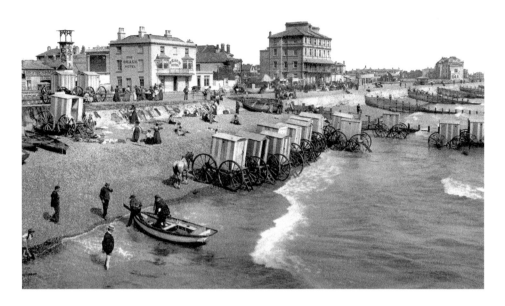

Bognor Regis, the Esplanade, Looking East

The transformation of Bognor from a small fishing hamlet to a popular resort began in 1787, when wealthy Southwark MP Sir Richard Hotham purchased an old farmhouse and 1,600 acres of land to fulfil his grand scheme. Princess Charlotte visited, as did numerous aristocrats. The middle classes followed and the town grew apace. The above post-1890 view was taken from the pier, which opened in 1865. Opposite the Beach Inn, later a hotel and now a restaurant, Mary Wheatland (1835–1924), who saved many swimmers from drowning, operated the bathing machines for nearly six decades.

The Carlton Hotel of 1890, prominent in the above view, stands just west of Mountbatten Court (1953) in the modern photograph.

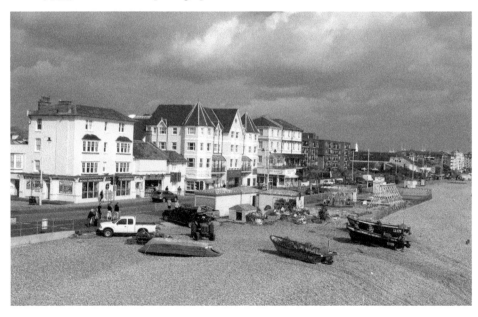

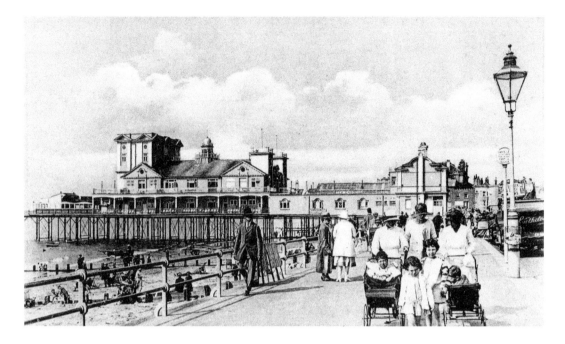

Bognor Regis, the Esplanade and Pier

This anonymously published postcard dating from the late 1910s or early 1920s gives us a good view of Bognor Pier from the east. The structure, obscured in the September 2011 photograph, has seen many changes down the years, most notably the removal of the domed turret from the pitched roof, as is evident in these pictures. In 1976 the elaborate windowed fly tower was also removed on safety grounds. The two towers at the entrance have, however, survived.

On the right behind the lamppost in the early picture, a Southdown single-decker stands near the bus stop.

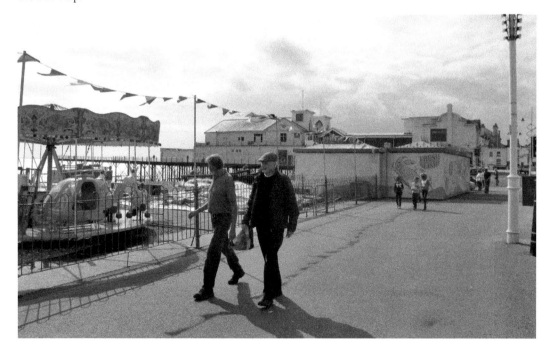

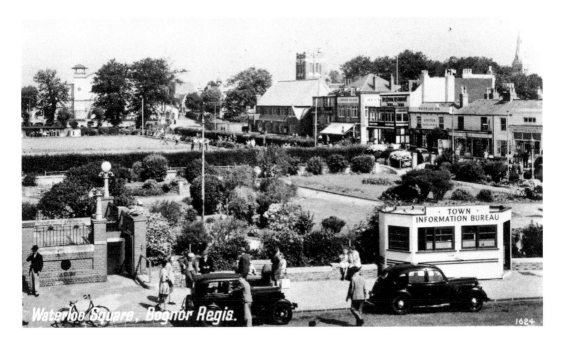

Bognor Regis, Waterloo Square, East Side

It is hard to imagine that as late as 1920 livestock grazed the field around which Waterloo Square was built. The sepia postcard was posted on 28 June 1948 and shows us, at top left, part of the pavilion of 1922 used for dances and plays. It was demolished in 1949. Also lost, in 1962 to make way for a car park, is the tower of St John's Anglican chapel, visible on the right. The chapel proper had been demolished in 1892.

In today's view, in which the Fitzleet House tower block is prominent, the Waterloo Inn and Methodist Church survive, although Crazy Golf is now played where there were once gardens.

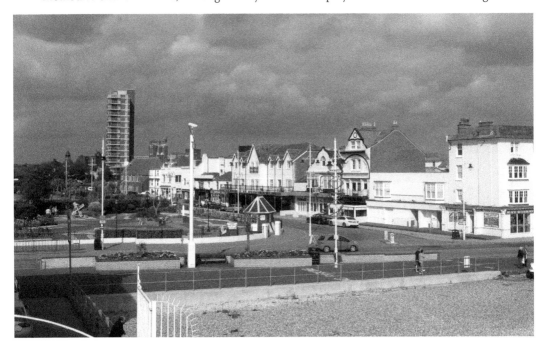

81

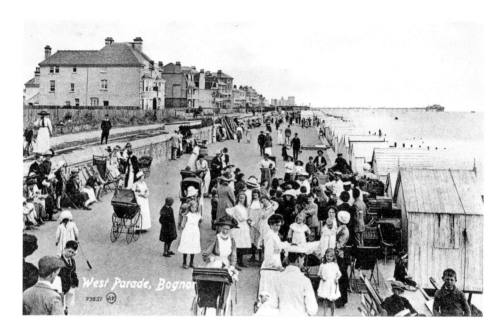

Bognor Regis, West Parade and Marine Drive West, Aldwick

These two pictures could hardly form a greater contrast, even allowing for an exceptionally busy West Parade with a predominance of children and young people. Vacant land, an empty coast road, beach huts and a distant full-length pier (it is today much truncated) are the major differences at this Bognor/Aldwick border.

In today's view, the popular Waverley public house was once, local patron Eddie Baldock told me, a big tea shop with a toyshop and mini arcade. The hotel is the Navigator, which enjoys a favoured position. Out of sight on the left are the very attractive Marine Park Gardens.

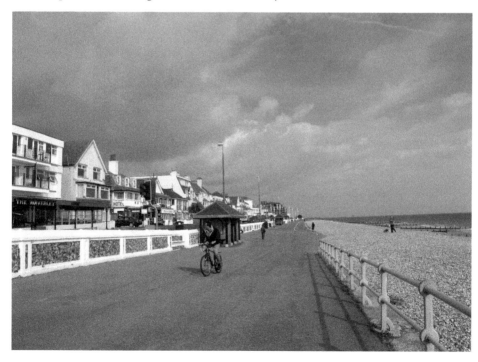

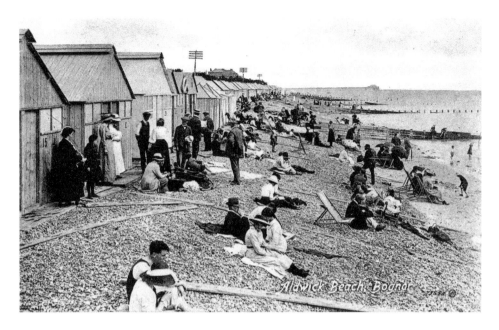

Aldwick

A little way to the west we are again presented with a striking juxtaposition of scenes. So many early postcards of this quiet suburb depict a crowded beach but today the throng of holidaymakers is replaced by a lone beach hut owner carrying out autumn maintenance work.

Nearby stands the exclusive Bay Estate, dating from 1928 and advertised as 'a nice type of seaside residence and for the retired wishing to reside in a peaceful neighbourhood, not invaded by trippers and charabanc parties'. Its social centre from 1932 to 1972, when it was sold for development, was the Tithe Barn, which stood at the junction of Tithe Barn Way and Fairway. The Marine Park Gardens, already mentioned, are adjacent to this beach also; they opened in 1935.

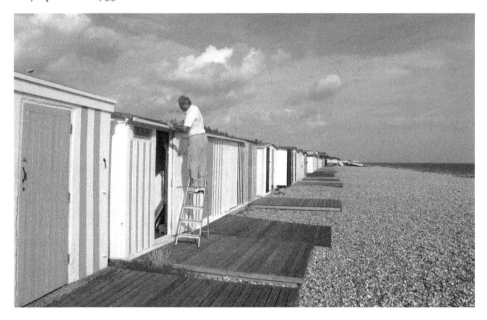

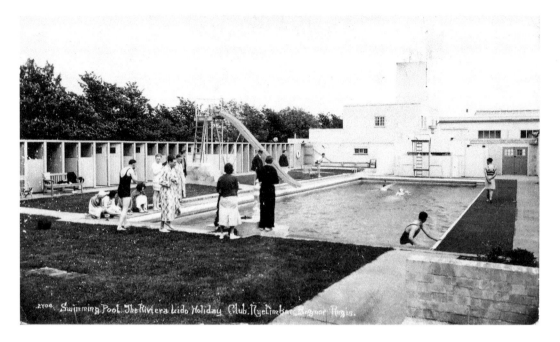

Swimming Pool. The Riviera Lido Holiday Club. Nyetimber, Bognor Regis.

Pagham, The Riviera Lido Holiday Club

This holiday centre, with its substantial brick chalets, bowling green, swimming pool, courts for tennis, squash and badminton, children's playground and other amenities, was open by 1938. On the eve of war, the sender of the above postcard lamented 'Having to leave here for evacuation ... I could weep... I wish Hitler at the bottom of the sea.' The complex was demolished and replaced with housing in the mid-1990s; Tabard Gate and the surrounding roads all bear Chaucerian and Tudor names.

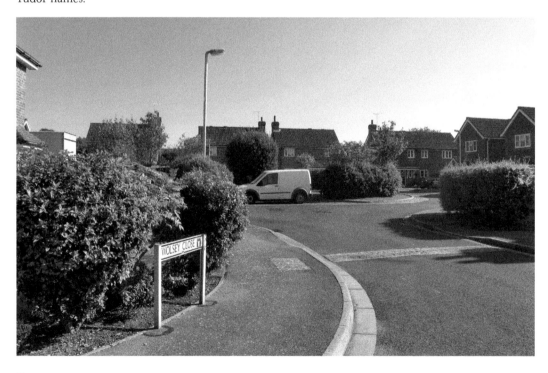

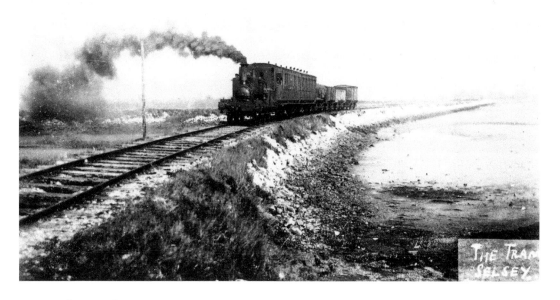

Pagham Harbour

Incredibly, Pagham Harbour was once a flourishing seaport – but that was in the Middle Ages. Coastal erosion at Selsey Bill led to the harbour becoming choked with debris by the nineteenth century. The artificial shingle barrier of 1876 was breached in a great storm in 1910, turning the creek into a grassy salt marsh which is now a valuable nature reserve.

The single-track Hundred of Manhood and Selsey Tramway opened in 1897 and ran eight miles to Selsey beach from near Stockbridge Road, Chichester. Later called the West Sussex Railway, it closed in January 1935. Above, *Morous* nears Selsey with a mixed train, some time after 1924.

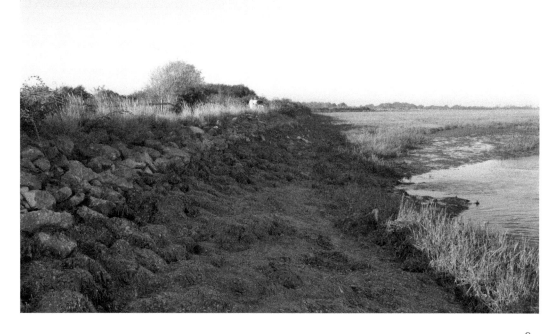

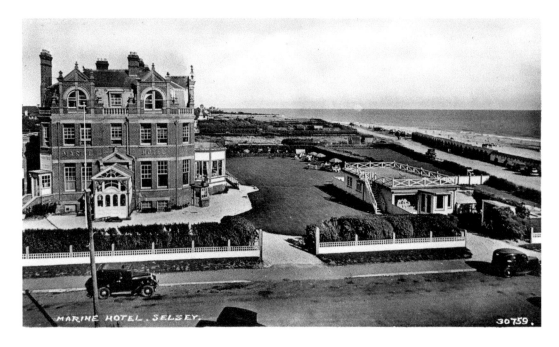

Selsey, Marine Hotel

The low-lying Selsey peninsula has been subjected for centuries to erosion, which in the distant past even claimed a cathedral, a monastery and a deer park, while in modern times beach huts and holiday homes have been the victims. The elevated slipway, erected in 1920, on top of which a lifeboat house was added five years later, initially ended 25 metres from the shoreline but now ends over 150 metres out to sea.

It was not, however, erosion that claimed the rather grand Marine Hotel, pictured here in 1947, but fire. The blaze destroyed the building in 1958 and housing now occupies the site.

Earnley, Sussex Beach and New Beach Holiday Camp

Four miles south-west of Chichester lies the civil and ecclesiastical parish of Earnley, known for the Butterflies, Birds and Beasts Centre and the historic Somerly smock windmill, currently undergoing restoration.

Sussex Beach (above), skirting the seashore, is a park of leasehold holiday bungalows. It also includes some buildings of the former 30-acre New Beach Holiday Camp, which was opened in 1925 by the Lyndhurst family and operated by them until 1960, when it was taken over by Butlins. The complex was sold in 1974. A 1960s promotional booklet for New Beach extolled the numerous facilities offered by the Camp and promised 'no regimentation'.

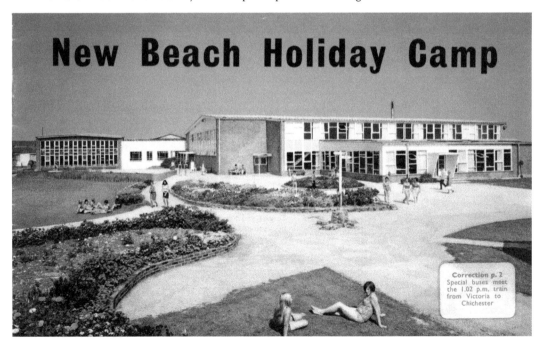

New Beach Holiday Camp

Correction p. 2
Special buses meet the 1.02 p.m. train from Victoria to Chichester

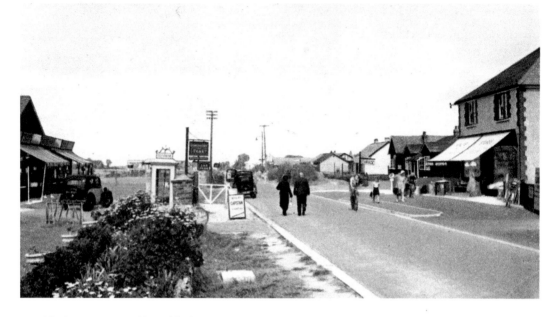

Bracklesham, Sea Road/Bracklesham Lane

Merged with East Wittering, Bracklesham – often loosely referred to as Bracklesham Bay – is a small but popular resort (especially with surfers), noted for its broad sands at low tide and its fossil-rich shore. A Pontins holiday camp opened here in 1947 but was sold in the 1980s. It closed in 1985 and the site is now housing. Another holiday centre, Gibsons, is today's South Downs Holiday Village in Bracklesham Lane, which caters only for the over-fifties.

The large detached property on the right is Moby's fish and chip shop, opposite which the Bracklesham Diner continues the refreshment tradition.

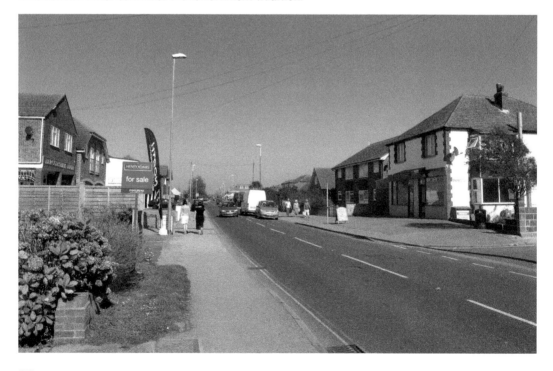

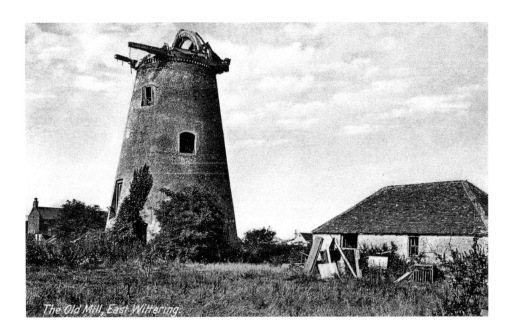

The Old Mill, East Wittering.

East Wittering, the Mill

East Wittering's four-storey windmill, off Church Road, was first mentioned in 1810 and worked by wind until 1895. The tower was burnt out in May 1975 and the windshaft fell within it. The grain store on the right in the above undated early postcard eventually collapsed. The mill has long been in the hands of the Redman family (Edward is recorded as the miller in 1887). Cyril, born in 1932, has lived alongside it since he was six months old and recalls lead being removed from the top for war purposes in 1941/42. The structure is today surrounded by housing but this photograph taken from Cyril's garden affords a striking view.

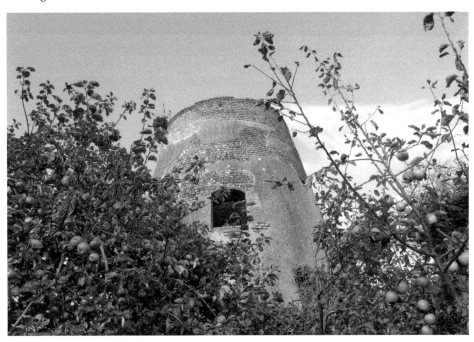

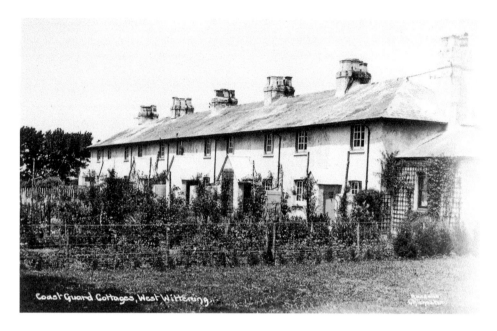

Coast Guard Cottages, West Wittering

West Wittering, Coastguard Cottages

The beach at West Wittering, near the mouth of Chichester Harbour, is famed for its sand dunes. It is one of the cleanest in the country and so popular that on occasion traffic queues in high summer extend the entire length of the Manhood Peninsula to the Chichester bypass and beyond. However, the area is very vulnerable to erosion and flooding – work on new sea defences is scheduled for the spring of 2012.

The mid-nineteenth-century coastguard cottages, with their gabled porches and slate roof, lie well inland in Coastguard Lane; numbered 1–9, they have been Grade II listed since 28 January 1986.

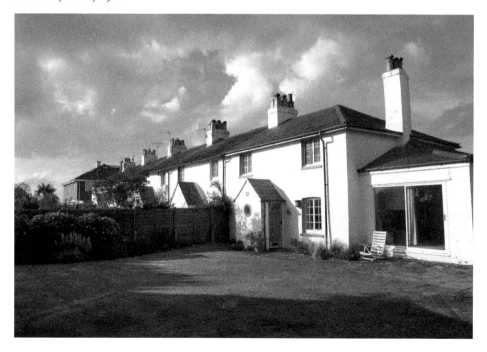

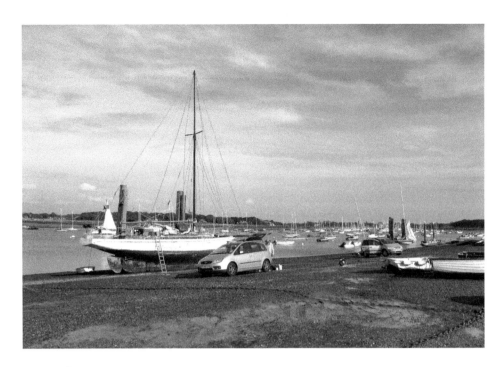

West Itchenor

The ancient parish of West Itchenor lies within the Chichester Harbour AONB, designated in 1964. Its twin, East Itchenor, was destroyed by fire after an outbreak of the plague. With a population of only around 500, West Itchenor is noted above all for pleasure boating; the Sailing Club was founded in 1927 and the village is home to the Haines Boatyard and the Northshore Yacht Company.

Dominating the above photograph, taken from the hard, stands the 40-foot *Wanderer* of 1886, one of the last long-keeled racing yachts. It has been maintained and sailed since 1963 by John Blase (pictured) and his partner Diane.

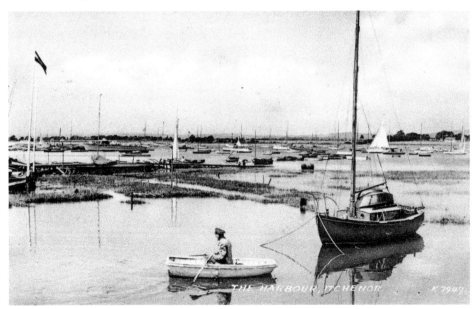

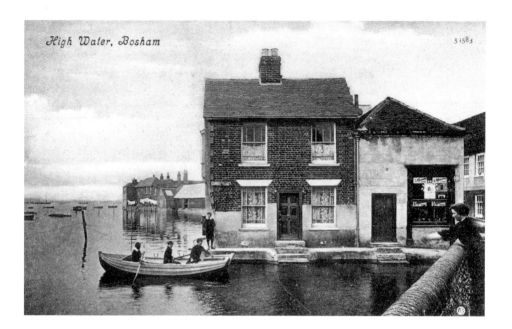

High Water, Bosham

5 4583

Bosham, Shore Road and Bosham Lane

North of West Itchenor and tucked within the tidal Bosham Channel lies the ancient village of Bosham (pronounced Bozz'm), a popular centre for sailing and walking and a sanctuary for migrating wildfowl. Seafaring and boatbuilding were once the chief occupations here and many cottages near the water were formerly fishermen's homes.

Of the two adjoining properties above in Bosham Lane, that on the right was Follett's Stores, owned by many generations of the same family. The properties were rebuilt in 1947 and today comprise the Mariners coffee shop and picture gallery on the ground floor and two flats on the first floor.

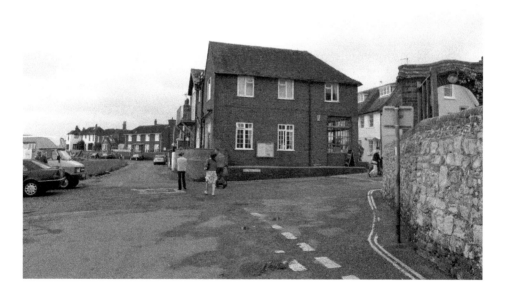

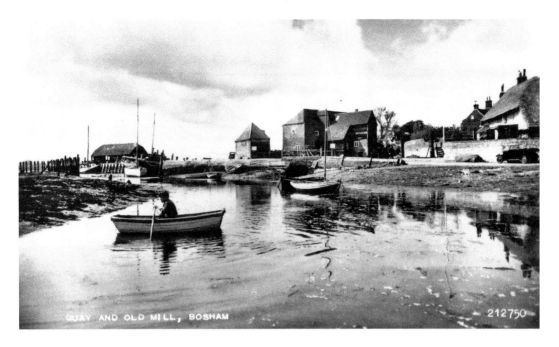

Bosham, the Quay and Old Mill

A short walk westwards along Shore Road brings us to the Quay area, depicted in sharp detail by the photographer of the Valentine postcard above. The barn-like structure on the far left is the Raptackle, leased by the Bosham Sailing Club as a starting platform for races and for the storage of club gear. The Manor of Bosham's Quartermaster's Office is the building in the middle of the old picture, while the large mill beside it has become the sailing club's headquarters (the watermill ground animal feed until 1925, finally closing in 1936). On the far right is the thatched Quay Cottage, once two homesteads occupied by fishermen.

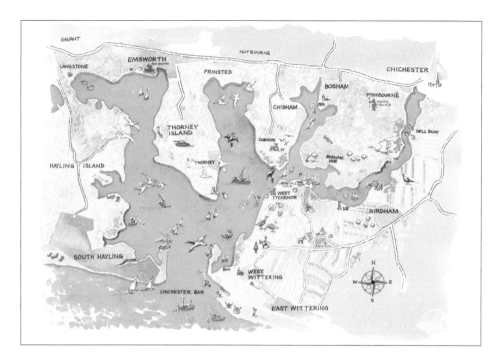

Chichester Harbour and Canal

The colourful artist-drawn map above of Chichester Harbour shows a number of the locations described on recent pages. The boundary between West Sussex and Hampshire runs from between Emsworth and Prinsted, then west of Thorney Island and down through the Chichester Bar.

Below is an attractive line-up of houseboats on Chichester Ship Canal captured on camera by Scottish visitor Duncan Brown. The 4-mile long canal opened in 1822 and was part of the network connecting Portsmouth to London. Last commercially used in 1906, it was formally abandoned in 1928 and is now a leisure-orientated waterway. Plans are afoot to restore its entire length.

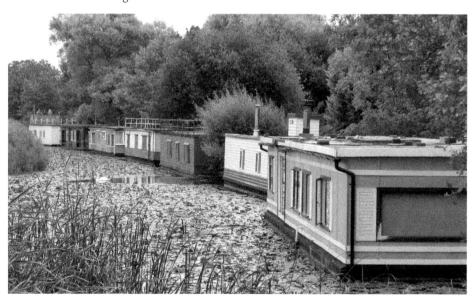

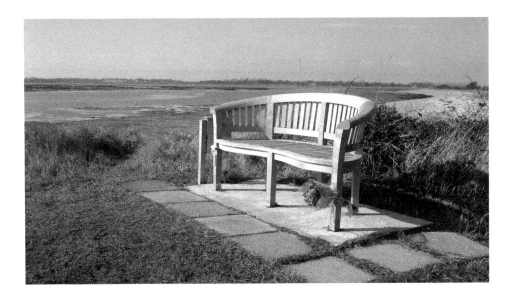

Thorney Island
Originally in Hampshire, Thorney Island is known for its military base, into which the village of West Thorney has been incorporated. The island is a valued nature reserve and a coastal footpath encircles it. It is separated from the mainland by a narrow channel called the Great Deep. The airbase here was important in the Second World War and after – the RAF did not leave until 1976. The bench is a memorial to twenty-five-year old Acting Lance Corporal Steven Jones from Fareham, who died on 30 January 2005 following the loss of an RAF C-130K Hercules aircraft over Iraq. Another bench nearby commemorates Sean 'Vic' Reeve, who was killed in Afghanistan in 2008.

Select Bibliography

Andrew, M., *Sussex Coast*, Photographic Memories of Britain Series (2003)
Bailey, P., *Newhaven in Old Picture Postcards* (1983)
Botha, A., *The Crumbles Story* (2006)
Briffett, D., *Sussex Murders* (1990)
Bromley-Martin, A., *Chichester Harbour – Past & Present* (1991)
Carder, T., *The Encyclopaedia of Brighton* (1990)
Goodwin, N. D., *Hastings & St Leonards Through Time* (2010)
Gordon, K., *Seaford Through Time* (2010)
Hawkes, J., *Sussex Coast from the Air* (2008)
Lyndhurst, D., *Bishopstone and the Lost Village of Tide Mills* (2001 & 2008)
McGowan, I., *Portrait of the Sussex Coast* (2008)
Middleton, J., *Hove and Portslade Through Time* (2009)
Scrivens, L. and C. Wright, *Hurrah for Hastings* (2009)
Skyworks, *Sky High Sussex – An Aerial Journey* (2007)
Surtees, J., *Eastbourne's Story* (2005)
Williams, R. and M. Green, 'Battling the Sea in West Sussex' in *Picture Postcard Monthly* (April 2011)
Williams, R. and M. Green, 'Battling the Sea in East Sussex' in *Picture Postcard Monthly* (July 2011)
Wolters, N. E. B., *Bungalow Town – Theatre & Film Colony* (1985)

Counties of East & West Sussex

10 miles (approx)

Index of Places